IMAGES
of America
MT. WASHINGTON
AUTO ROAD

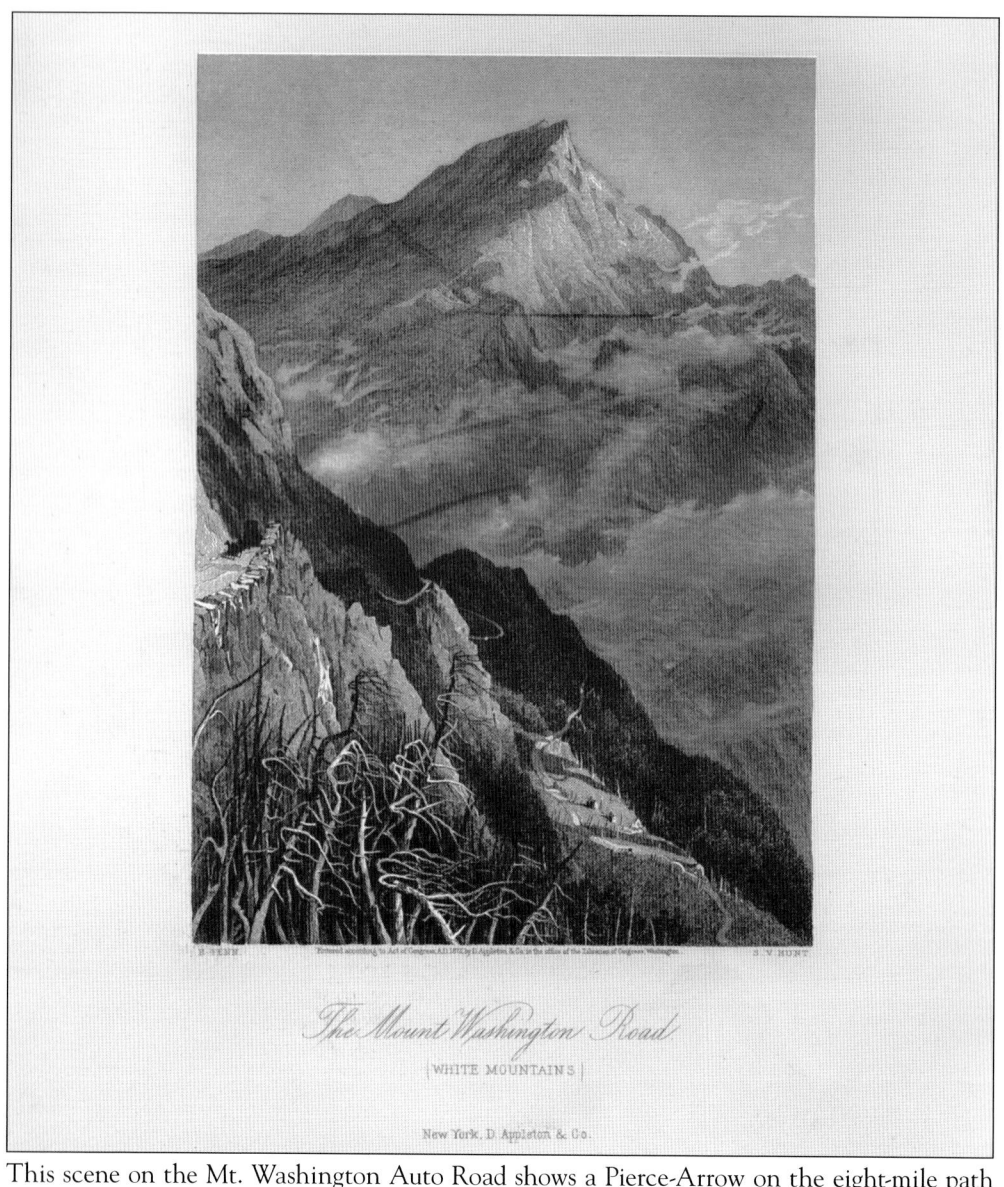

This scene on the Mt. Washington Auto Road shows a Pierce-Arrow on the eight-mile path to the summit of the Northeast's highest peak, about 1925. In these early years following the transition from the horse-drawn era to motor vehicles, increasingly diverse types of autos could be found winding their way up Mount Washington's famous "Road to the Sky." (Courtesy of the Wemyss collection.)

ON THE COVER: This scene on the Mt. Washington Auto Road shows a c. 1915 motorist on the eight-mile path to the summit of the highest peak in the Northeast. (Courtesy of the Philbrook collection.)

IMAGES of America
MT. WASHINGTON AUTO ROAD

Steven Caming

Copyright © 2014 by Steven Caming
ISBN 978-1-4671-2165-1

Published by Arcadia Publishing
Charleston, South Carolina

Printed in the United States of America

Library of Congress Control Number: 2013951887

For all general information, please contact Arcadia Publishing:
Telephone 843-853-2070
Fax 843-853-0044
E-mail sales@arcadiapublishing.com
For customer service and orders:
Toll-Free 1-888-313-2665

Visit us on the Internet at www.arcadiapublishing.com

Dedicated to the past, present, and future employees of the Mount Washington Summit Road Company, who have devoted themselves to keeping this mountain of memories up and running for more than 150 years.

Contents

Acknowledgments		6
Introduction		7
1.	When Horses Ruled the Road	9
2.	The Carriage Road Becomes the Auto Road	33
3.	Working on the Road	47
4.	The Glen Houses	63
5.	On the Summit	77
6.	An Eventful History	107

Acknowledgments

No author can approach a project like this without recognizing that virtually all of the needed materials must be discovered, not created. When delving into historical archives and personal collections for Mount Washington materials, it was amazing to consider the efforts made by long-gone photographers who struggled with rudimentary equipment, difficult weather, and alpine conditions to get images that are priceless today. Men like the Kilburn brothers, John Soule, S.F. Adams, Winston Pote, Guy Shorey, and Harold Orne, among so many others, have left us views of our world in their time. Thankfully, a few dedicated collectors and historians have preserved these images and were willing to share them. My sincere thanks to Andrea Philbrook for making the remarkable collection of her late husband, Douglas Philbrook, former president of the auto road, available for this project. The collection of Mount Washington historian and current auto road general manager Howie Wemyss was also utilized, as were his inexhaustible enthusiasm and knowledge of the subject. Unless otherwise noted, all images are courtesy of the Philbrook collection.

I must acknowledge the dedicated and passionate team of people who make up the staff of the auto road today; each of them brings something of their unique nature to this place, which in turn brings an eight-mile stretch of mountain road to life for the hundreds of thousands who find their way here each year. Simply put, they care about this mountain, this road, and the history in the making that takes place each year. It is an honor and a privilege to count myself among their ranks.

Lastly, for providing a lifetime of inspiration, encouragement, and love to their sometimes eccentric dad, thanks to my daughter, Jess, and my son, Spencer.

INTRODUCTION

Mount Washington is a mystical and remarkable place—a mountain of compelling beauty, a mountain of history, and a place that has created countless moments that stir and inspire the human soul. When it opened to the public on August 8, 1861, it became the first man-made attraction in America and continues to draw those who seek a sublime moment of peaceful contemplation or an opportunity to challenge themselves and the Northeast's highest peak.

At only 6,288 feet tall, it has made more history than mountains three times its height, as it became a proving ground and a playground for generation after generation of inventors, adventurers, and record seekers trying new technologies to tackle the historic path to the summit. Some records were on the more frivolous side (such as the man who walked up counting his steps—16,925, to be exact), though some were serious feats of engineering excellence. Perhaps the most notable portent of things to come occurred on August 31, 1899, when Freelan Stanley and his wife, Flora, made the first-ever motor vehicle ascent of Mount Washington. Stanley's little steamer was known as a "Locomobile," and on that day, Mount Washington's age of motorized travel had begun.

For many, Mount Washington provides that chance to make or break a record, but for the vast majority of visitors, it is an opportunity to be inspired by its beauty and to share a timeless moment of reflection. "Man seems so small, when you look at the universe," said Pres. Ulysses S. Grant, observing the view from the summit in 1869. Less poetic but true to his character, P.T. Barnum called the summit view "the second greatest show on earth!" Other writers, painters, and photographers have been equally inspired through the decades and have left endless glowing representations of their time in the world above the tree line.

When Gen. David Macomber applied to the New Hampshire Legislature in 1853 for a charter to build a road up Mount Washington, America was a different place: there were only 31 states in the Union and 25 million people in the whole of the United States, Abraham Lincoln was president, and the Civil War was just beginning. The Road to the Sky commenced operation more than 150 years ago, then known as the Mt. Washington Carriage Road, but it would be half a century before the change from actual horsepower to machine-made horsepower took place, with 16 years before the transcontinental railroad commenced operation and decades before the first autos and airplanes appeared. Nevertheless, tourists were finding their way to the White Mountains in ever-increasing numbers and have never stopped coming.

It was the opening of the St. Lawrence & Atlantic Railroad (SLR) between Montreal and Portland, via Gorham (to ship wheat to an ice-free port), that led the way. Following in 1851 was the rail line from Portland, Maine, to Gorham, New Hampshire, which then led to a road being pushed through to the glen. Also in 1851, John Bellows began construction on what would eventually be the first Glen House in Pinkham Notch, and the railroad also continued its investment in the area with the construction of the Alpine House in Gorham.

In 1852, Col. Joseph M. Thompson bought Bellow's incomplete hotel and a large swath of land in Pinkham Notch. After finishing construction, Thompson opened the first Glen House and began guided trips up his new bridle path, which was partially funded by the railroad.

Locals from Lancaster and Jefferson also completed the first Summit House in 1852, and suddenly, Mount Washington was a destination unto itself. It took eight years and two companies to eventually complete the work, which was originally contracted at a cost of $8,000 per mile for the eight-mile road. Extensive surveying work and years of blasting solid rock ledge with black powder eventually resulted in an average grade of 12 percent and a road alignment that was so well laid out that, even with all of today's modern technologies, it could not be improved upon.

The first tolls were collected in the summer of 1860 for passage over the lower half of the road, while construction pushed on toward the top. As many as 80 men, mostly Irish immigrants, spent 10–12 hours on the road each day, not counting walking to and from the work site—in every weather condition imaginable. Finally, on August 8, 1861, the Mt. Washington Carriage Road officially opened for business.

There were dramatically good and bad times ahead. At one point, more than 120 horses and 20 mountain wagons were employed to ferry visitors up and down the road, in addition to the private carriages, coaches, and wagons utilized by the general public and the ever-expanding list of hotels and inns that were cropping up throughout the region.

The first Glen House, which at one time boasted the longest veranda in the world at 450 feet, was a fine example of the grand hotels to follow, before it burned in 1884. Over the years, Glen Houses number two, three, and four were built and also burned to the ground.

The continuing and growing popularity of a drive up Mount Washington ensured that the carriage road business continued, with or without a hotel at the base to support it. Following Stanley's first automobile ascent in 1899, horses continued to rule the road for another decade or so, leading inexorably to the inevitable changeover. By 1912, the carriage road transitioned to the auto road, with its first automobile, a 1908 Thomas Flyer, used to ferry passengers. A Knox, Peerless, and Chandler followed, eventually leading to the first fleet of Packards. This is not to say that there was no resistance among the road owners and managers to the new-fangled contraptions. For the 1904 Climb to the Clouds, it took a special vote of the directors "to allow automobiles and any motor vehicles to pass over the road on July 11, 1904–July 16, 1904" but with a stipulation that "at no other time shall they be allowed on the road." Finally, in 1908, it was voted "to allow automobiles to pass over the road as the directors might decide." The toll for a car with two passengers was $3.

With the age of the automobile well under way, horse-drawn wagons became a thing of the past. Into the 1920s, a fleet of white Pierce-Arrow touring cars became the elegant new way to ascend the mountain, followed by Ford woodies, Ford station wagons, Internationals, and eventually, a succession of custom-built 12-passenger vans that continue to serve as stages today.

The mountain bears silent witness to the history that has been made on its slopes—the human joy and drama, victories and defeats—but each generation leaves its mark, like a ring on a tree. As each year recedes before another, those times are not lost from memory, just from view.

Perhaps the greatest achievement of the Road to the Sky is that, since 1861, it has provided absolutely anyone, at any age, a chance to share a compelling perspective of the world we live in, to see a glimpse of ourselves how we were, to experience a timeless moment, to breathe deeply the alpine air, and to reflect briefly on those who came before and will follow after. This is Mount Washington.

One

WHEN HORSES RULED THE ROAD

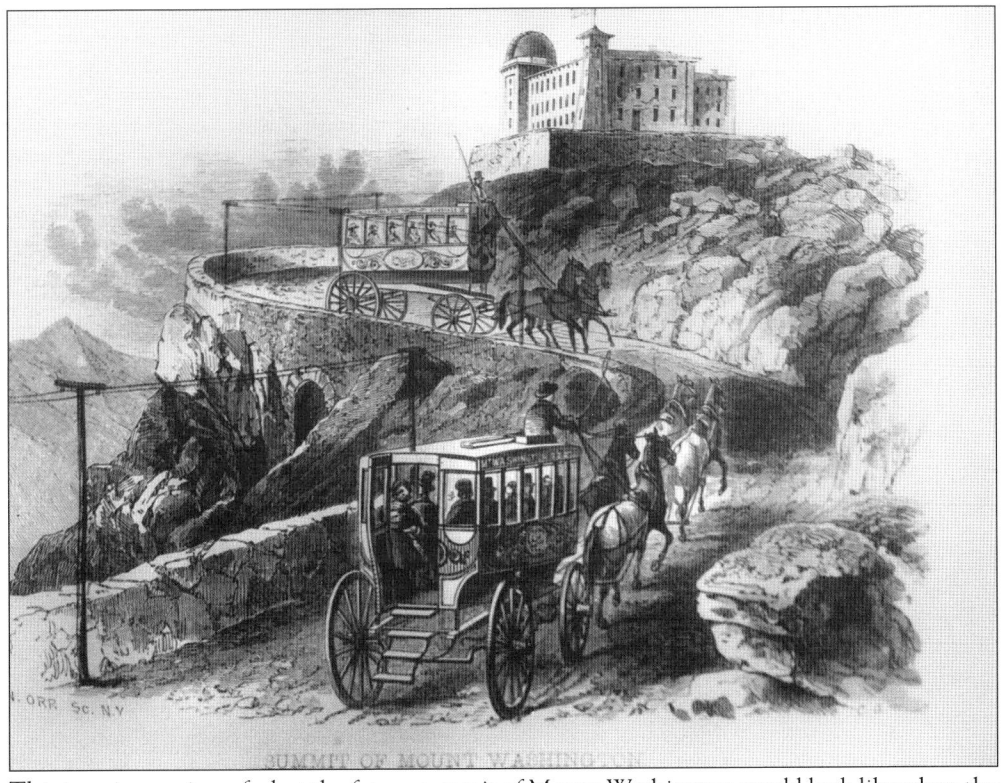

This imaginary view of what the future summit of Mount Washington would look like when the carriage road was finished appeared in *Ballou's Pictorial Drawing-Room Companion* on August 9, 1856, five years before the road opened. This was the fanciful vision of Gen. David Macomber, who obtained a charter from the New Hampshire Legislature in 1853 to build the road. The specially designed omnibus passenger stages were designed with two large screws on each end so the coach could be leveled going up or down the mountain. The design also included a leather strap lying on the floor of the carriage that could be pulled by any passenger, theoretically bringing the horses to an immediate stop. These omnibuses never made it off the drawing board, though a fleet of 12-passenger mountain wagons was eventually built by the famed Abbot-Downing coachworks in Concord, New Hampshire. As has often been the case, Mount Washington of the imagination must come to terms with the rigors and challenges of the actual world above the tree line.

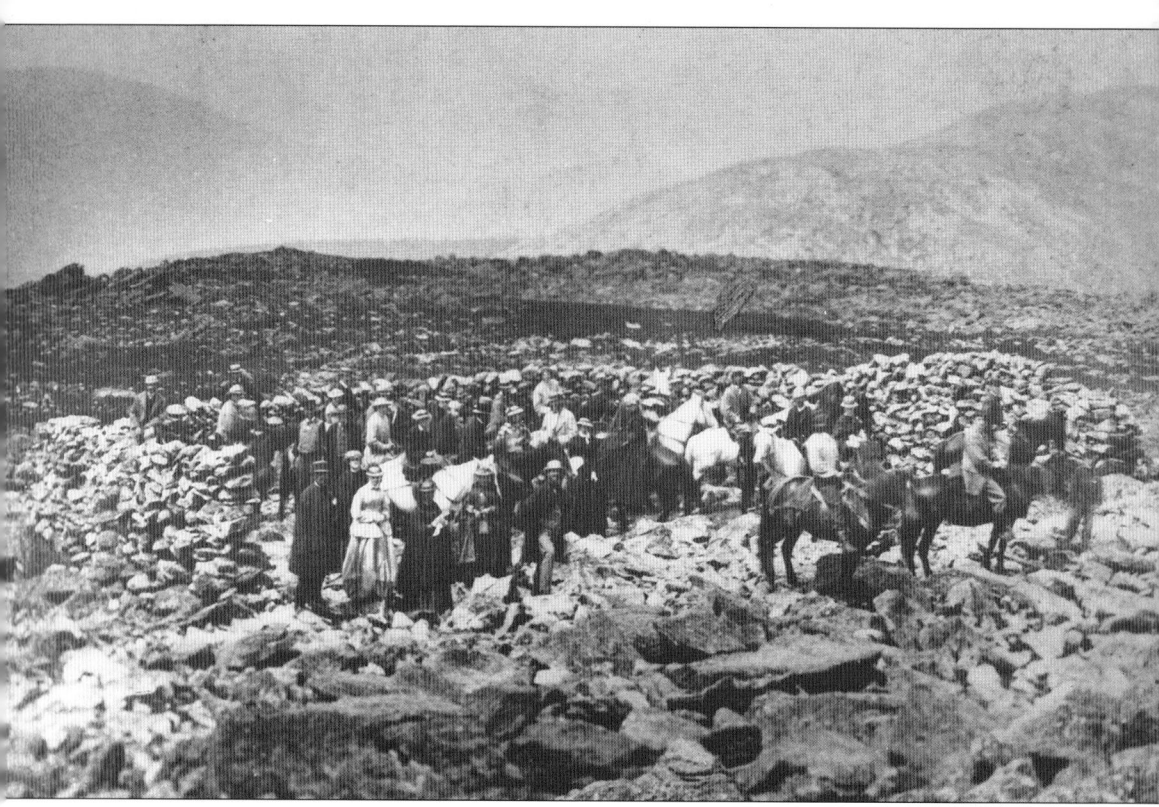

While Ethan and Abel Crawford constructed the first hiking and bridle path up Mount Washington as early as 1819, there were few who found and made the rough ascent in the early years. The path started near what had been the Crawford House, went up Mount Clinton, and followed the southern peaks of Pleasant, Franklin, and Monroe to Lakes of the Clouds and then up the summit. In later years, individual hotels had hiking and horseback tours to the top, and by 1852, the first rudimentary summit house began hosting overnight guests. The pony train pictured above shows a large group arriving in the mid-1850s, well before the carriage road opened to the public. A primitive stone corral can be seen, allowing the group some respite from a long day in the saddle. This would have been considered quite an adventure, especially for the ladies riding sidesaddle. Visitors to the summit during the early decades of the 1800s would have found precious little shelter or comfort.

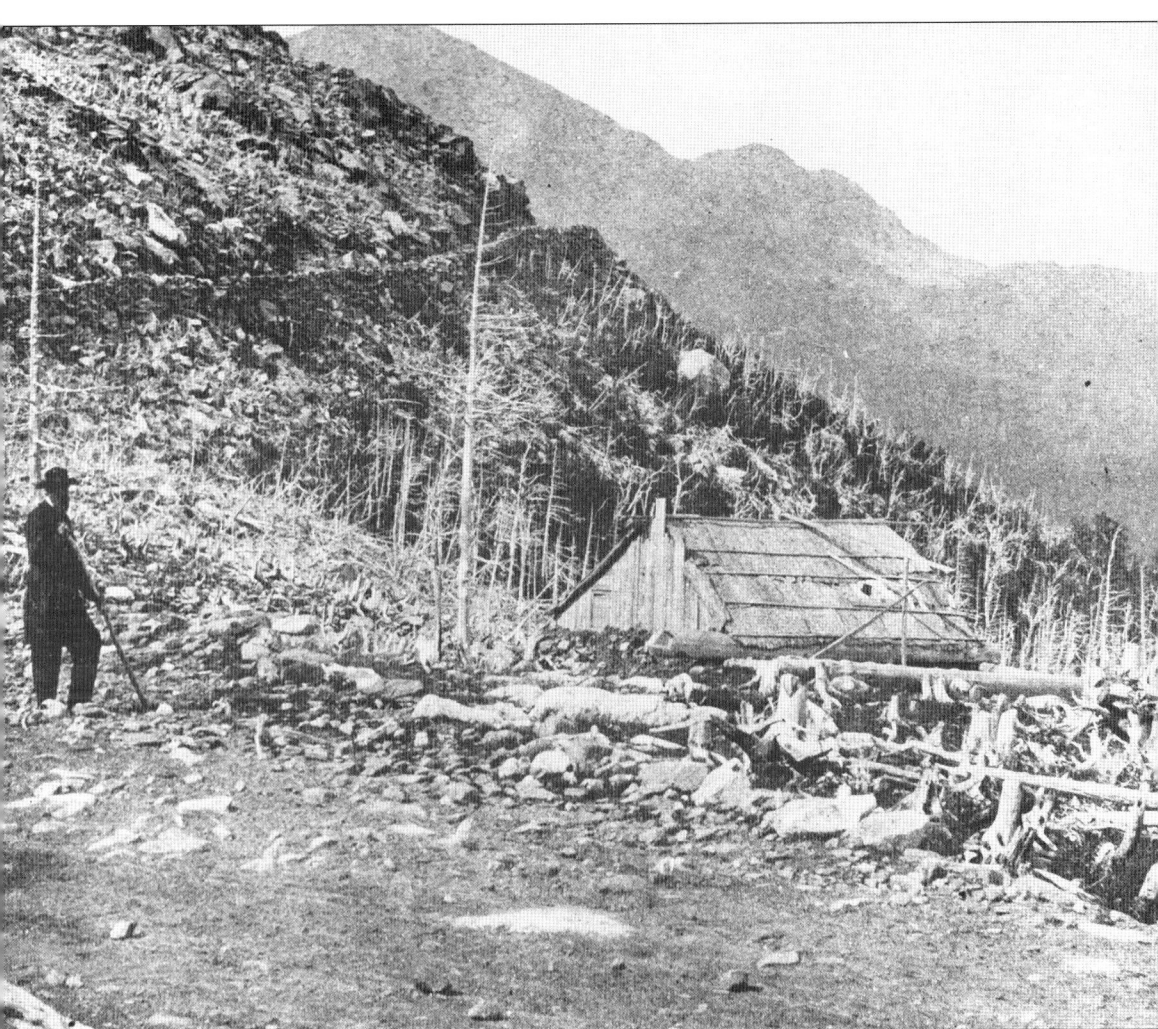

This is the only known photograph that exists of the road under construction, about 1855. The contract for construction called for an eight-mile road with an average grade of 12 percent. David Macomber hired civil engineer R.C. Ricker and Charles Cavis to survey the route. The construction contract (at $8,000 per mile) was awarded to John P. Rich and Dillon Myers, with Cavis serving as superintendent. These intrepid road builders faced a daunting challenge. As the planned mountain road was more than eight miles from the nearest railroad, everything had to be hauled to the work site by teams of horses and oxen. Thousands of blasting holes had to be hand drilled and filled with black powder in this era before dynamite. By 1857, the first four miles were completed, bringing the road as far as the ledge above what was now being called the halfway house. Unfortunately, the money ran out there, as did the backers' enthusiasm for the project. Work stopped, Macomber disappeared, and for two years, the project languished.

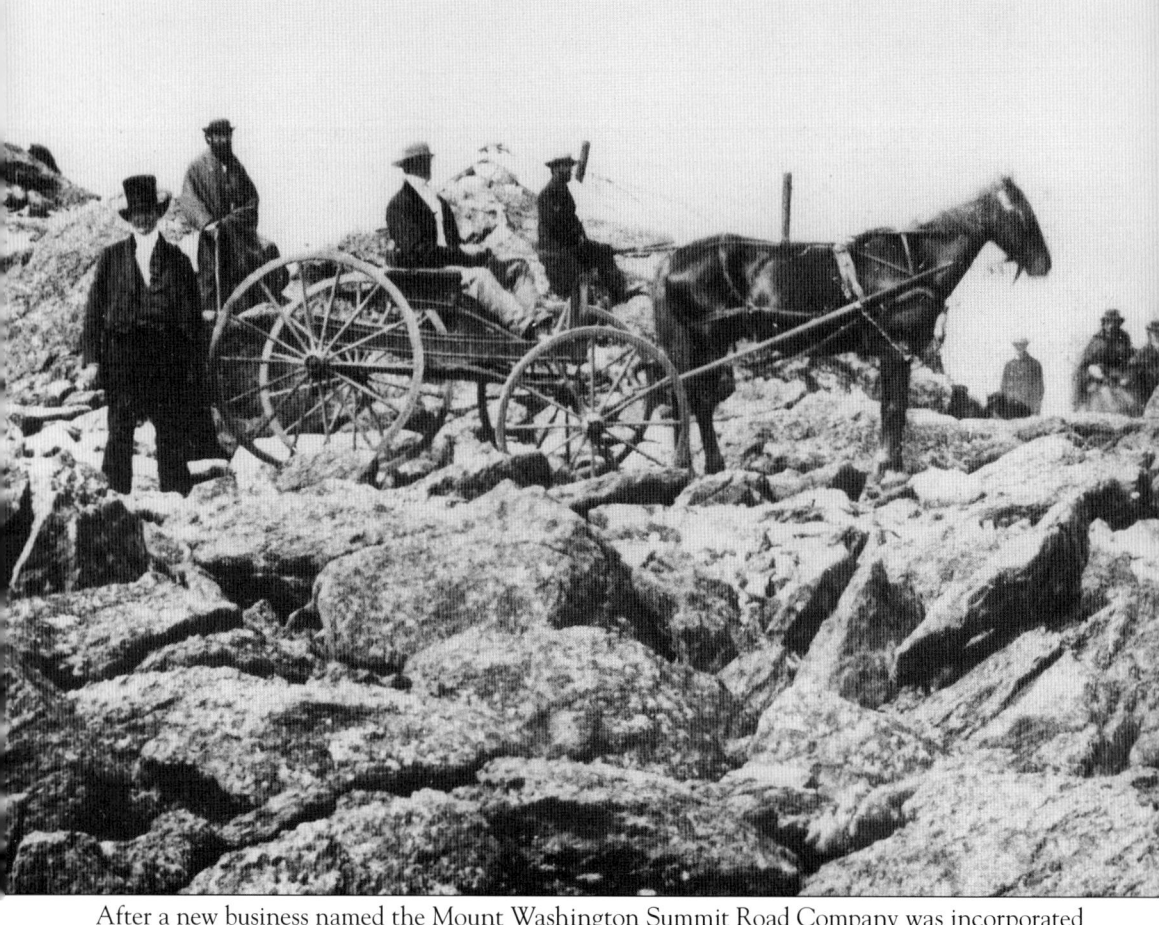

After a new business named the Mount Washington Summit Road Company was incorporated in 1859 to take over construction (backed by David Pingree, who owned great tracts of land in the area), the road's completion was assured. While the new carriage road would not officially open to the public until August 8, 1861, the proprietor of the first Glen House, Col. Joseph M. Thompson, decided that he would, in fact, be the first person to drive his buckboard to the summit. Thompson had a friendly rivalry and competition with the owner of Gorham's Alpine House, Col. John Hitchcock, over who would have the honor of a first ascent. The matter was settled when Thompson drove up on July 13, as this account from witness Ben Osgood confirms: "J.M. Thompson and a man with him were the first to go to the top of the mountain with any kind of four wheeled carriage, having to go one half mile over the bridle path from the end of the road where the workman were grading . . . It was a grand triumph, as they got to the top without a scratch or break."

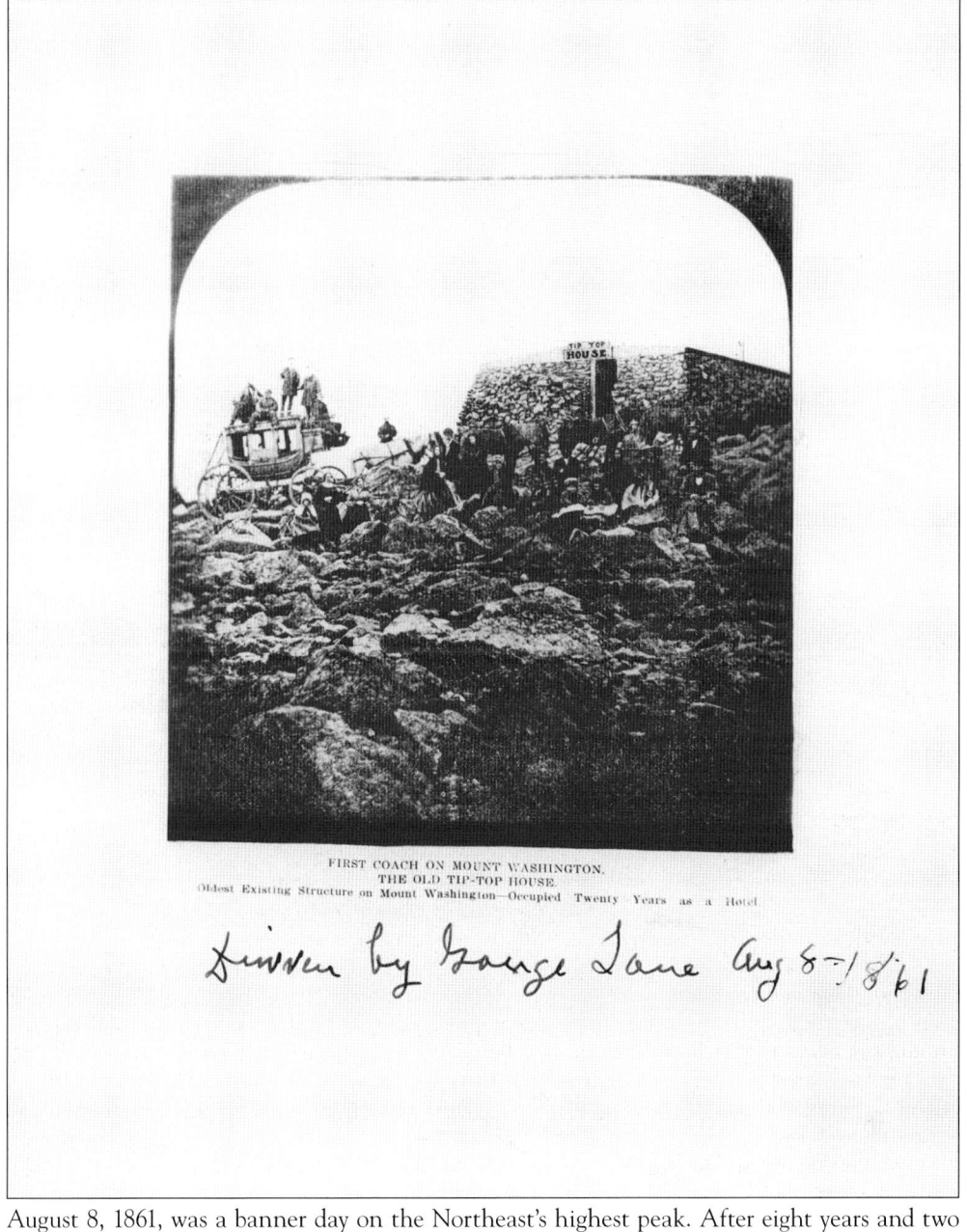

August 8, 1861, was a banner day on the Northeast's highest peak. After eight years and two different companies' efforts, the Mt. Washington Carriage Road opened for business. This rare image shows the first Concord Coach to ascend the mountain, alongside the Tip-Top House, which had been taking in overnight guests for nearly a decade when the road opened. This was the beginning of a golden age for the summit, which would experience rapid development in the ensuing decades, including a mountain-climbing railroad, various hotels, a newspaper office, weather observatory, and much more over time. The eight-horse coach pictured above was driven by George Lane, who later ran the Fabyan House stables. Among Lane's passengers were Joseph Thompson and his wife, owners of the Glen House, who spent much of the time on top of the coach waving an American flag.

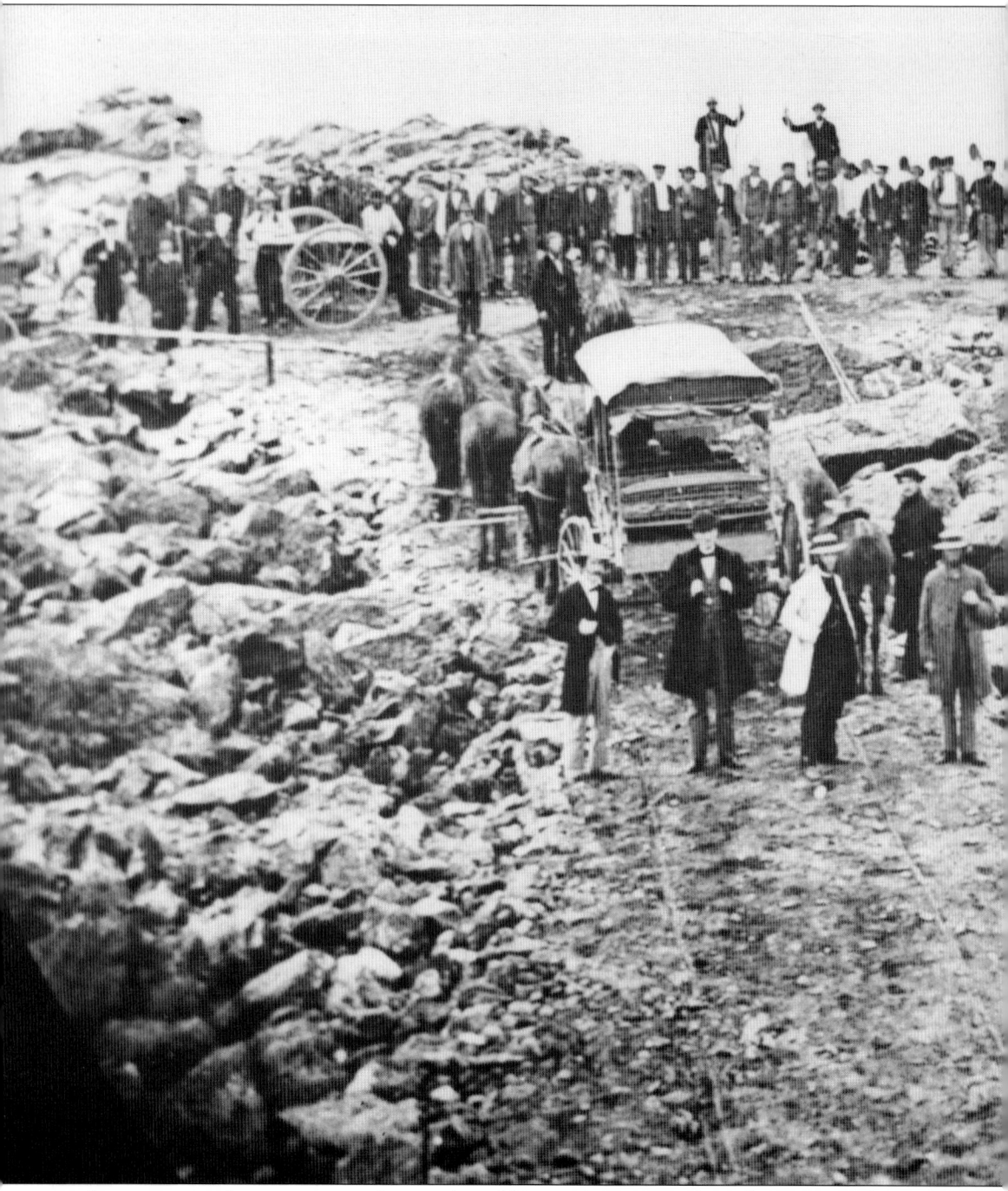

Carriages, coaches, wagons, and more than 200 people converged on the summit of Mount Washington to celebrate the momentous occasion of the road finally opening on August 8, 1861. Employees marched up the road carrying an American ensign and formed in a line, giving three cheers. A 13-gun salute was fired at 1:30, and many celebratory speeches were delivered. After photographs of dignitaries were taken, many of the road's laborers appeared carrying axes, shovels, and crowbars, the tools of the road-building trade, and posed shoulder to shoulder, as they had

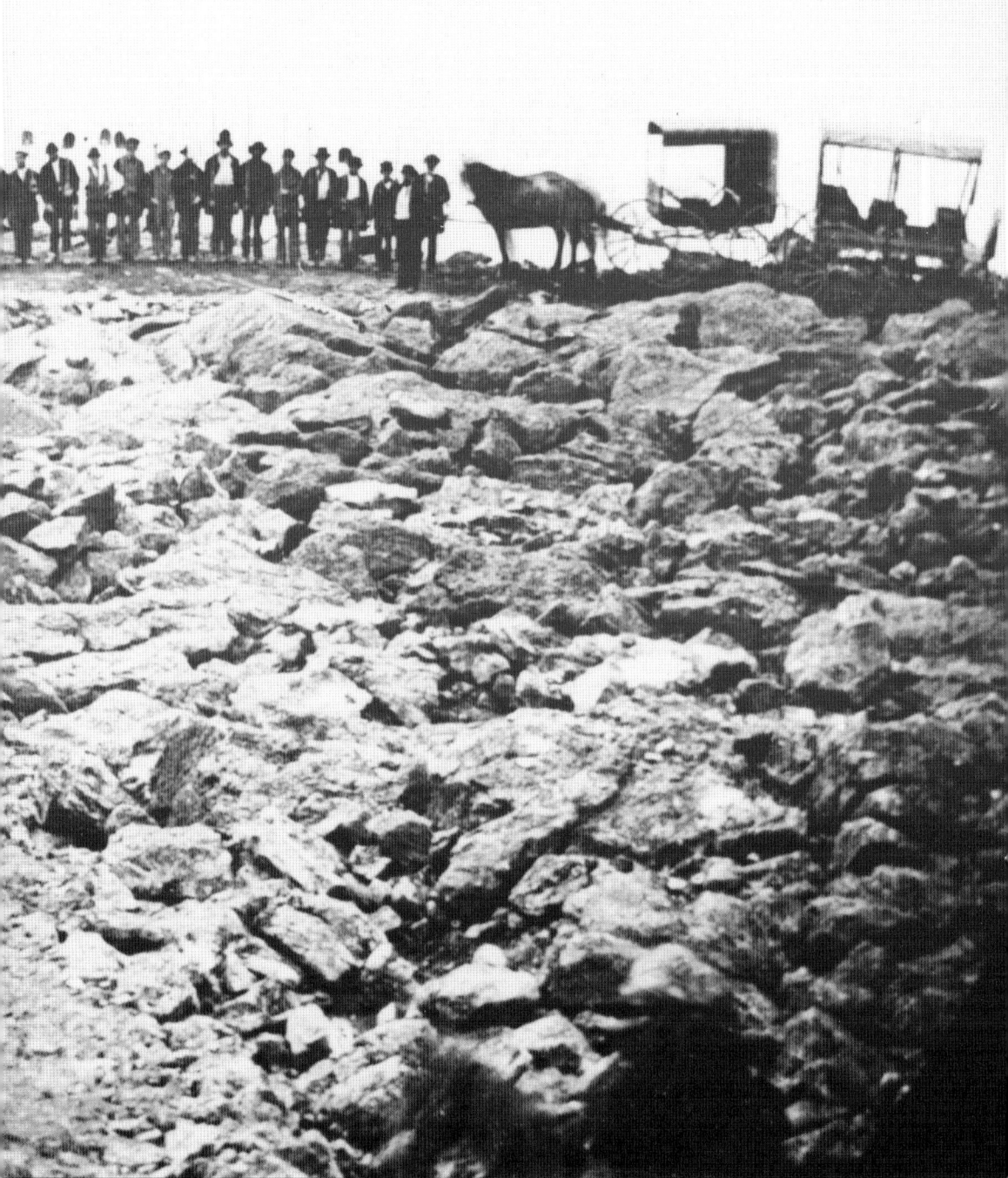

worked, for a picture that still evokes the magnitude of the unlikely achievement of that day. At a time in America when the Civil War had just begun and there were only 31 states in the Union, the nation's first man-made attraction became available to the public. The impending era of grand hotels, railroads, and a developing tourism industry would all contribute to the White Mountains' coming of age, and at the center of it all, as the beacon that drew all to its slopes, was Mount Washington and the carriage road.

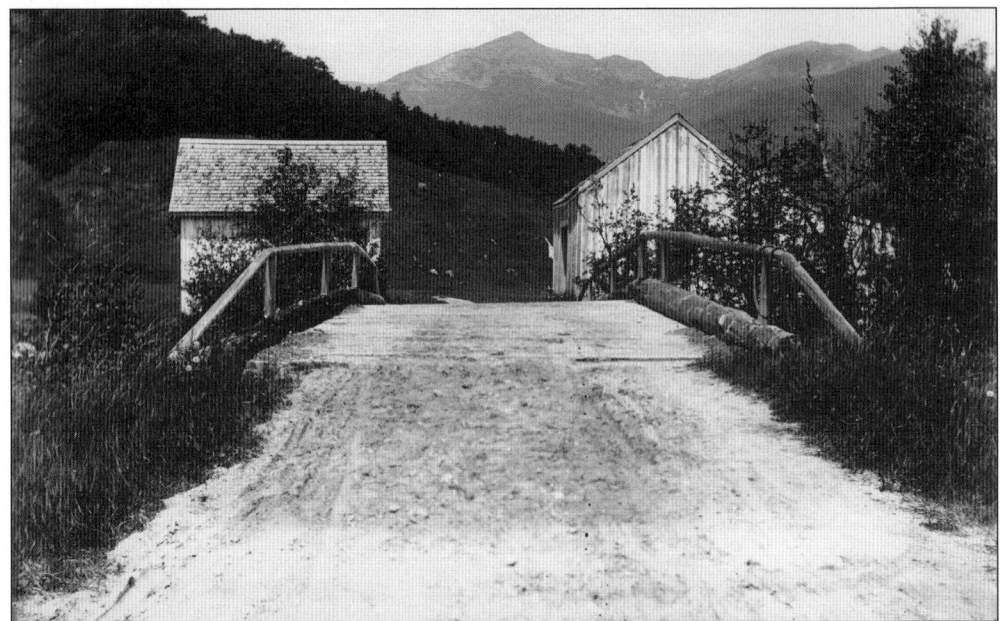

This simple wooden bridge over the Peabody River marked the entrance to the carriage road in its early years. The tollhouse on the left side would be the last stop before ascending to the world above tree line. The building on the right was the gatekeeper's cottage, even though there was no gate. These same two buildings from about 1860 are still in place today, though serving different purposes. The pointed peak in the middle is Mount Adams, with Mount Madison to its right.

Rutted by wagon wheels and in need of constant upkeep, the Mt. Washington Carriage Road is seen in this early view as it leaves the base area and begins the ascent to the 6,288-foot summit. In the 1870s, the American Telegraph Company (later AT&T) ran telegraph lines along the roadway to the summit, becoming the first in an endless series of communication-based companies who would eventually broadcast and/or transmit from the top of the mountain. The small visible sign in the lower right corner invites travelers to visit the Summer House, a gazebo just off into the woods that had a commanding view of the glen.

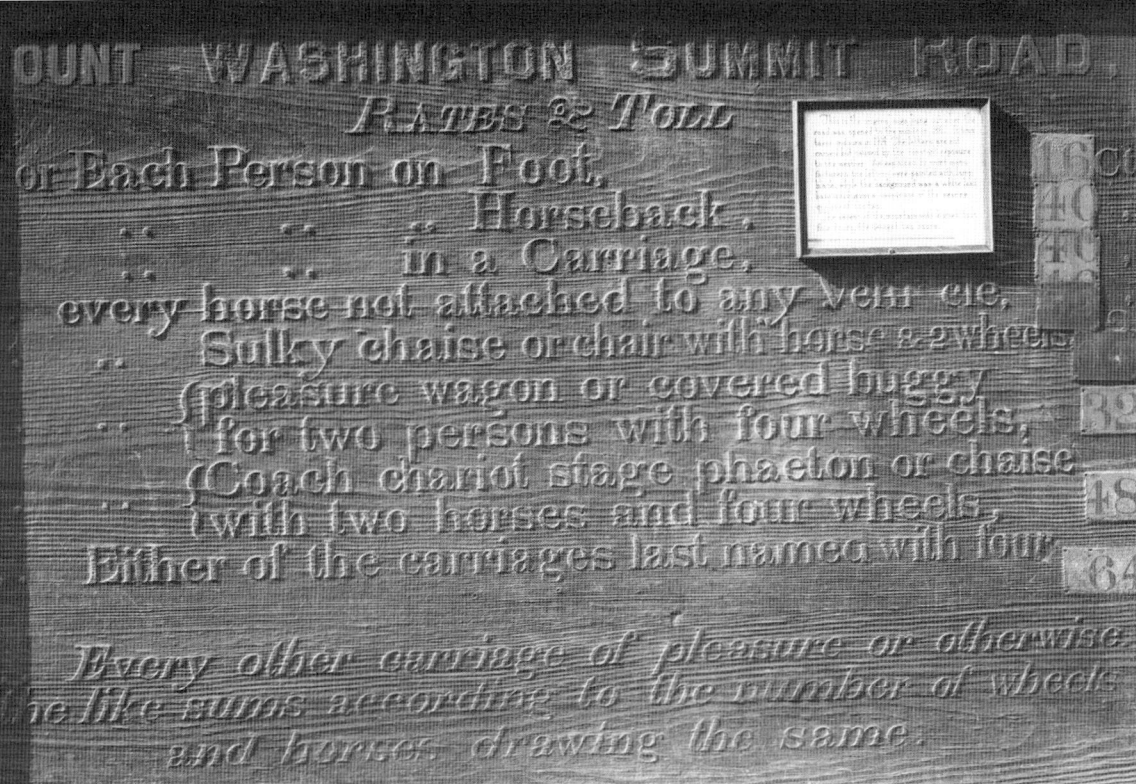

This is the original sign that greeted travelers wishing to travel up the carriage road when it opened in 1861. It was utilized through 1914, when the horse-drawn era came to a close. This wooden sign, despite its appearance to the contrary, was not carved, but worn by weather. The letters were painted using lamp black, while the background was finished in white lead paint, which was worn more dramatically by the harsh elements in this alpine environment. Whether ascending by foot, horseback, carriage, sulky, pleasure wagon, coach, chariot, stage, phaeton, or chaise, there was a special rate, though the difference between these conveyances was often nominal at best. This actual sign remains on display at the base of the auto road.

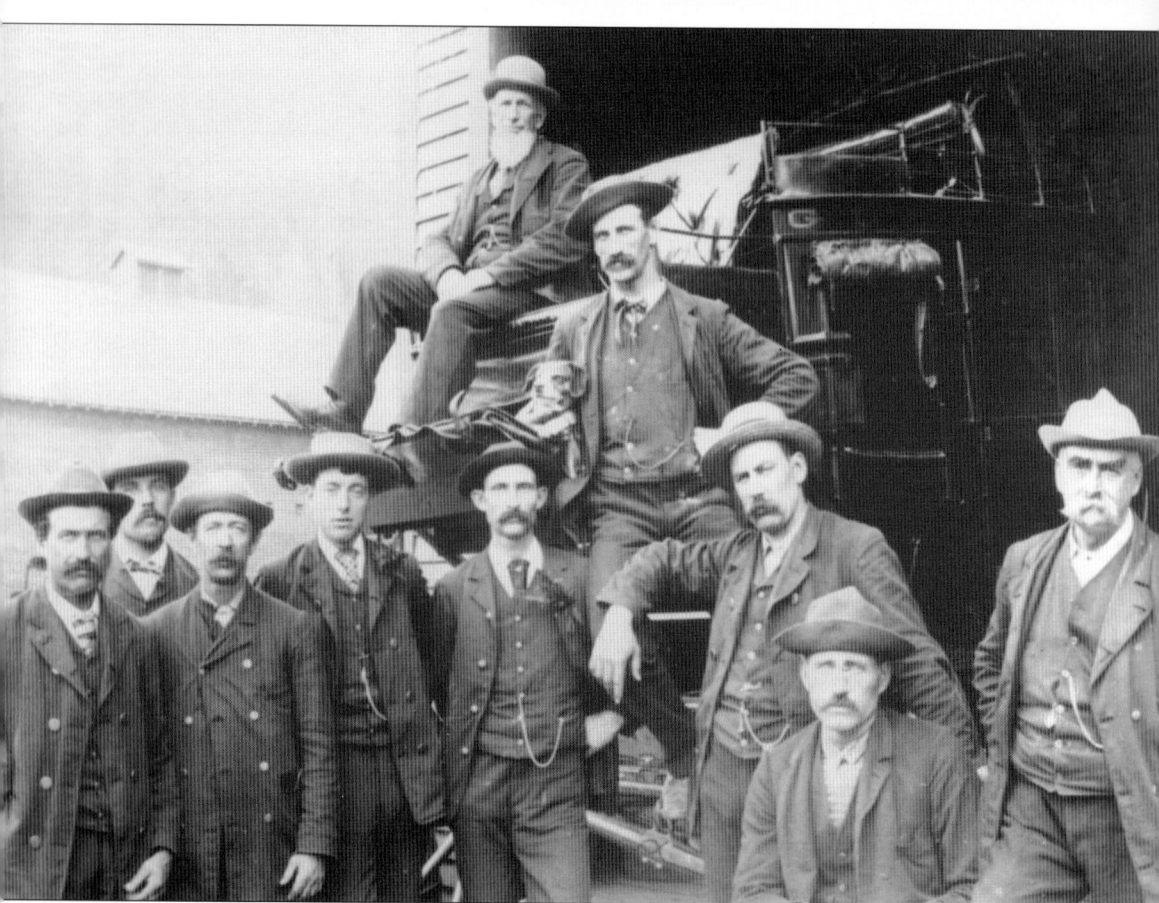

This classic image of the stage drivers (about 1875) captures some of the unique character that was the hallmark of these men. Every hat, every expression, and even their individual ties and watch fobs distinguished their unique style and personality, even when in uniform. Abbot-Downing coachworks of Concord specially designed the 12-passenger mountain wagons that traversed the carriage road to the summit of Mount Washington. Driving a six-horse team up this narrow mountain road was no small feat and required steady hands and nerves of steel. At a time when 120 horses and 20 mountain wagons were in use on busy days, one can imagine that the four-hour ascent and two-hour descent would have been quite an adventure.

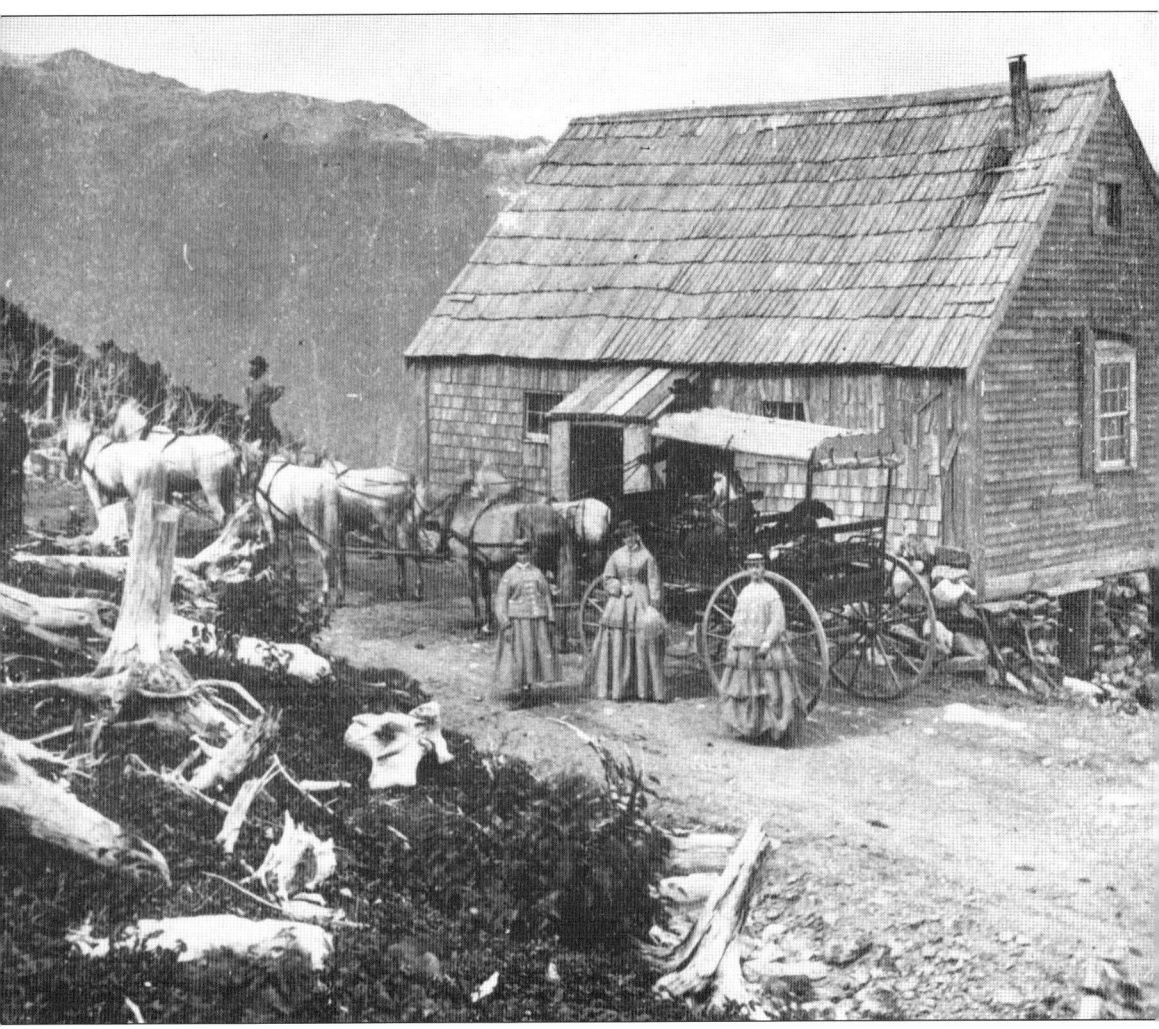

The first version of the halfway house was little more than a roof mounted over a small space for workmen who were building the road to retreat to in case of dangerous weather or spend a night if needed. The first structure was in place during construction of the initial four miles of road building, at which point the money ran out. When new road owners John Rich and Joseph Hall took over in 1857, they brought in David Pingree as a financial backer, who ensured the road's completion. During this time, a new halfway house was erected, as both a refuge and a tollhouse to collect from those who came to visit. By 1861, when the road opened and the six-horse mountain wagons began ferrying passengers, the halfway house was a regular stop during the ascent.

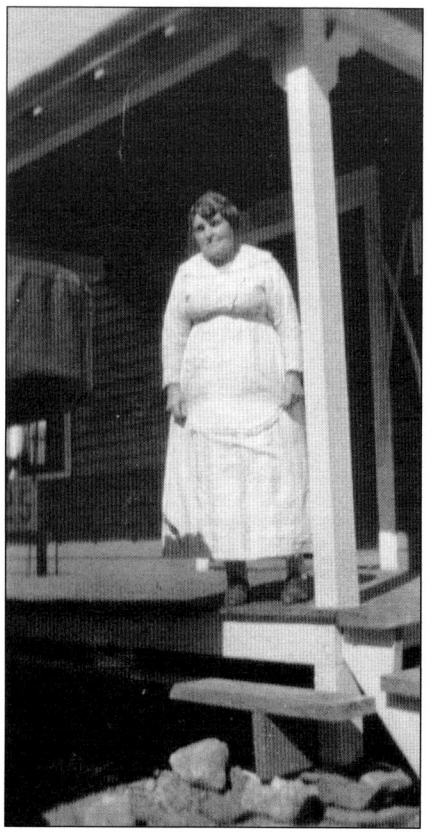

As the Mt. Washington Carriage Road continued to grow in popularity, a new halfway house was constructed, capable of offering a few more creature comforts for those who arrived on their way to the top. It also remained an important way station or shelter for those who worked on the road. The carriage driver pictured above is hauling a load of hay, either to halfway or to the summit. Like many of the other buildings on Mount Washington, this one was chained down, providing some additional security against the hurricane-force winds that continue to routinely blow over the mountain.

Her name was Mary Ames, but around Mount Washington, she was known as "Old Leather Lungs" for her capacity to yell at errant hikers or drivers who had passed her halfway house on the carriage road without paying the toll. At the age of 70 in 1923, "Mountain Mary" still spent four days at a time on her own up on the road, described by the *Boston Post* as follows: "Her nearest neighbors are the tawny, stealthy wildcats that prowl about her mountain door. Her greatest enemy, besides the wind which would tear to bits the staunchest ship that sails the seas, is the porcupine. Her front door opens toward the top of the mountain, 2500 feet above. Her back door, if she had one, would open over the gully, 4000 feet below."

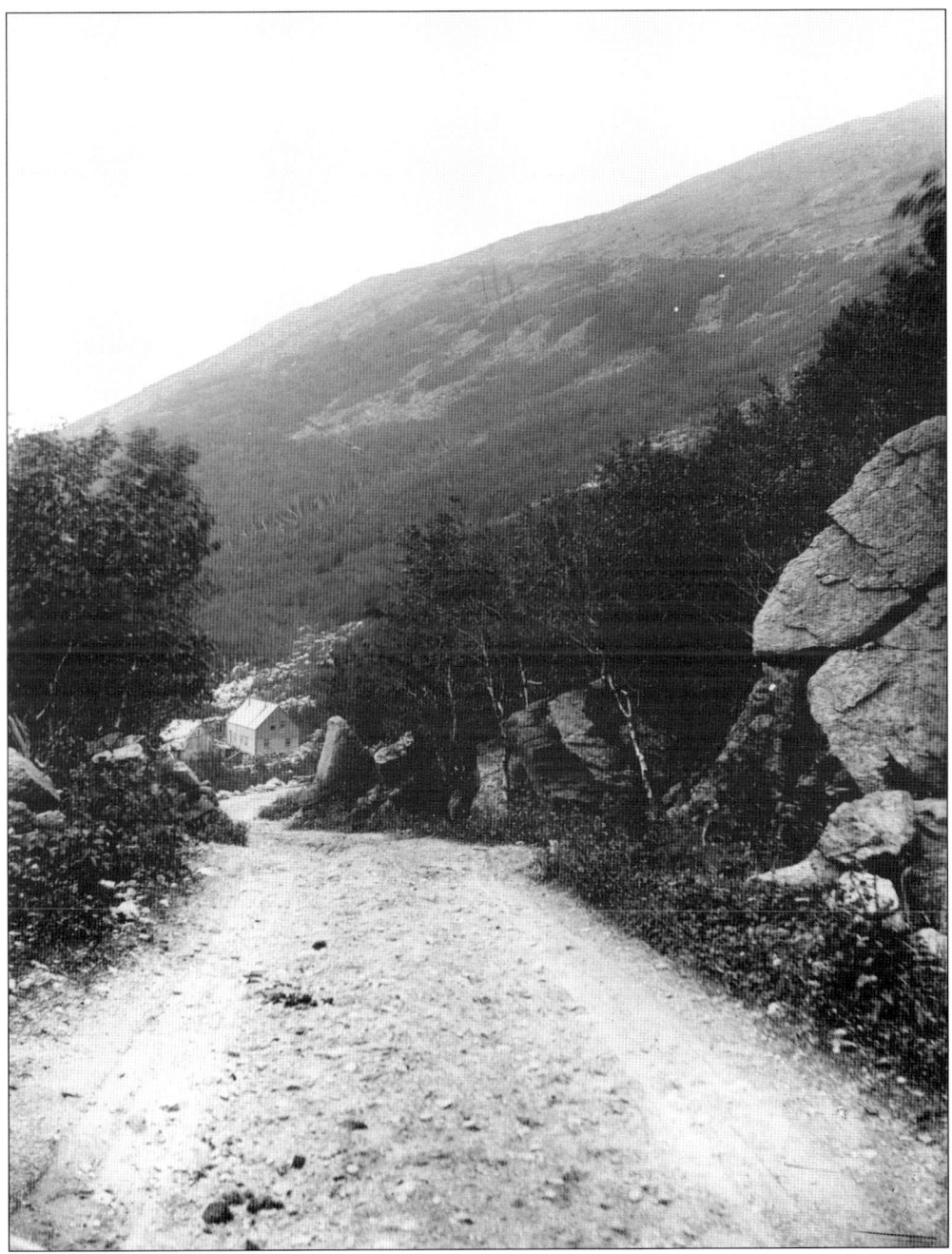

This early view of the halfway house located on the Mt. Washington Carriage Road gives some sense of the remoteness of this isolated outpost on the slopes of the Northeast's highest peak. Though it served its place in history, the isolation proved to be its undoing. Through the decades, the halfway house was raided time and again by hikers—some seeking shelter, others just breaking in because it was abandoned during the winter. Furniture, floorboards, and any other wood that could be pried off was burned in the stove, often leaving the building open to the elements. Unfortunately, these repeated incidents of vandalism left the building unfit for further use, and it was finally burned to the ground in 1984.

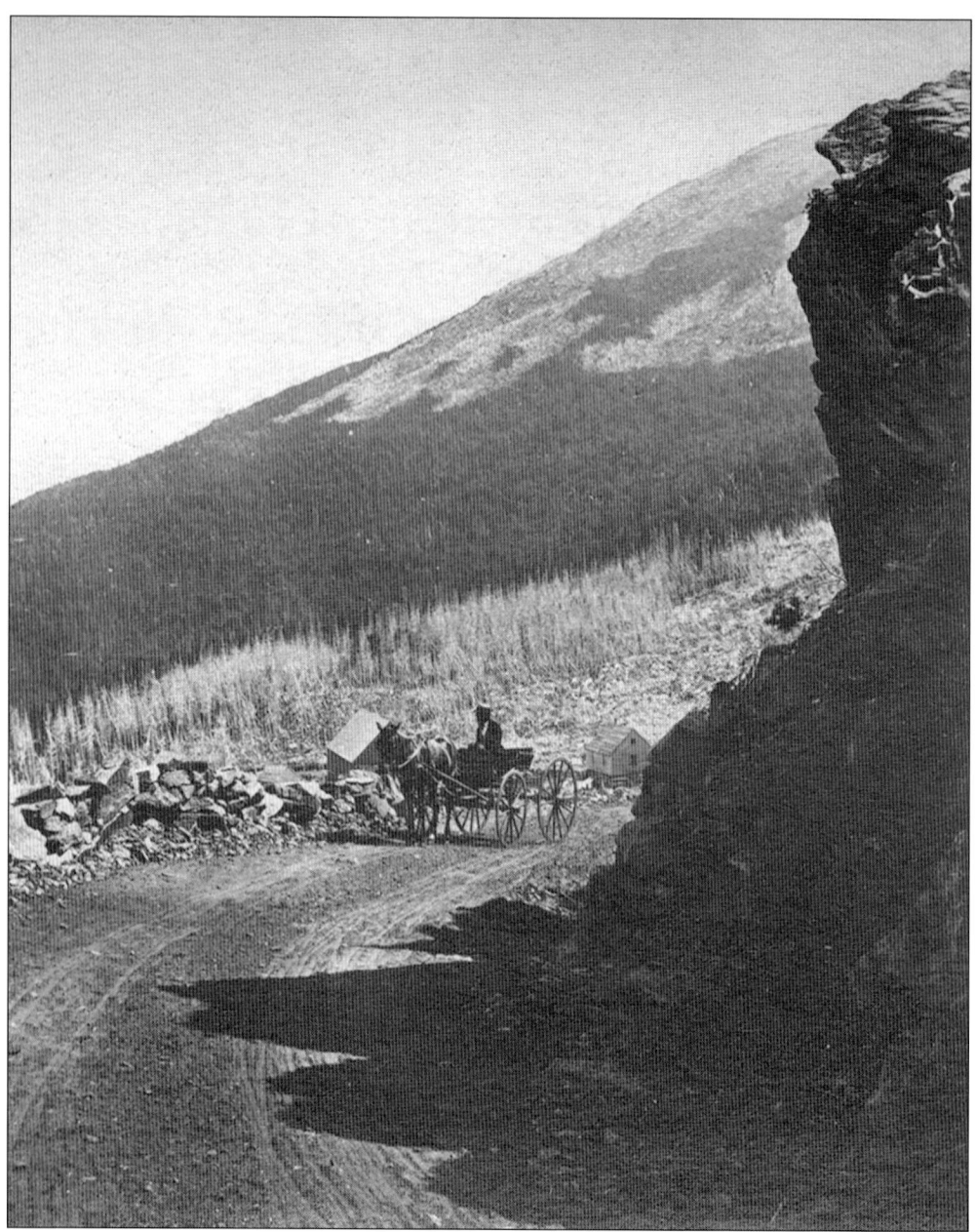

Once the carriage road was open to the public, all types of private horse-drawn vehicles found their way to the mountain, in addition to the Summit Road Company's fleet of mountain wagons. This driver stopped to reflect on the imposing view just above the halfway house. Even as late as the 1870s, the effects of the 1816 "summer that never came" could be seen on slopeside trees, which became known as the "silver forest," having never recovered from the damage of the killing frost that year and lowering the tree line considerably. Visible along the right side of the frame is the type of rock ledge that had to be blasted away to create the roadbed. (Author's collection.)

This pre-1900 view along the Mt. Washington Carriage Road shows Mount Jefferson (left) and Mount Adams (right). The American Telegraph Company poles (much shorter here than at the base) and wires can be seen clearly. One early famous visitor, author Louisa May Alcott, described her ascent in vivid terms: "Sometimes we looked up granite walls that seemed to shut out the sky, then into gorges that sink sheer down a mile or more and turned the brain giddy with a glance . . . The trees grew smaller and smaller as we went and the last miniature wood had something pathetic in it. The tiny trees were so like large ones in shape and age and though so stunted, had a desperate sort of hardihood in clinging to the scanty soil, as if bent on living though all the elements forbid."

These two very early views along the carriage road section known as "the Ledge" further illustrate the kind of boulder-strewn slopes the early road builders faced with picks, shovels, crowbars, and black powder. The image containing the two workmen shows them taking a break during the never-ending process of grading and repairing damage done to the road by weather and traffic. Original specifications for the road were as follows: "Eight miles, 16 feet in clear width, the outside of the road raised one foot higher than the inside . . . the grade of the road in no place exceeds a rise of one foot in seven, averaging one in 9 ½. The construction is after the best manner of the English McAdamized roads, there being from four to eight inches thickness of fine, broken stone over the entire surface. In places where there is any dangerous precipitancy, a heavy protection wall is built on the outer side of the road, three feet thick and 2 ½ feet high." (Both, courtesy of the Howie Wemyss collection.)

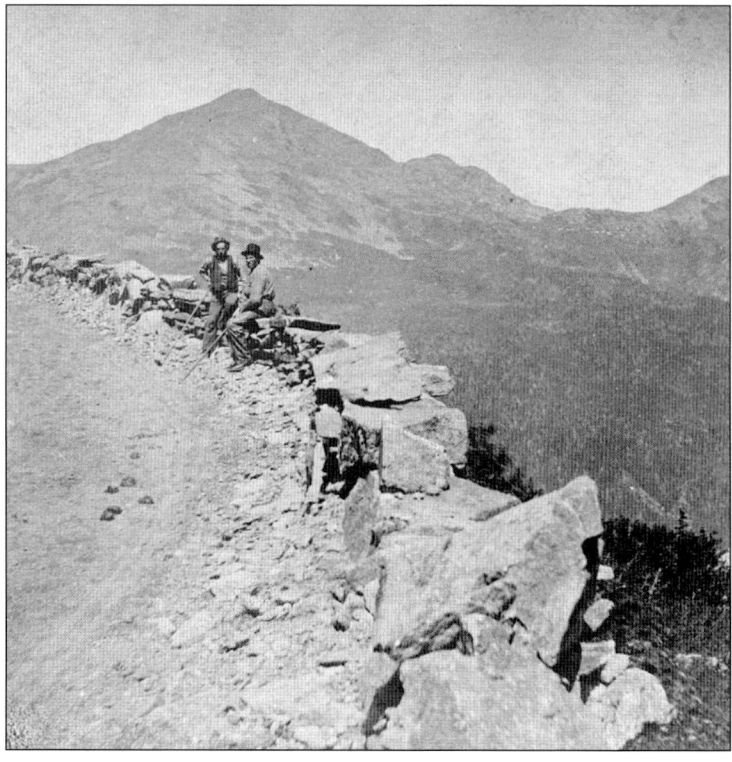

These two views of the company's own mountain wagons navigating the Mt. Washington Carriage Road illustrate the kind of horsepower needed to make it up and over the average grade of 12 percent. It has been noted that, on particularly windy days, passengers were often asked to help load rocks into the bottom of the wagon to help keep it from tipping over. Throughout the recorded history of the business, there has been only one fatal accident involving stage passengers, when a descending six-horse mountain wagon tipped over as a result "of too rapid driving" combined with too much "O-be-joyful" in 1880. At no place on the road could two of these large horse-drawn vehicles pass, so strategic pullouts were essential and could cause minor delays waiting for an up- or down-bound wagon to pass. (Right, author's collection; below, courtesy of the Howie Wemyss collection.)

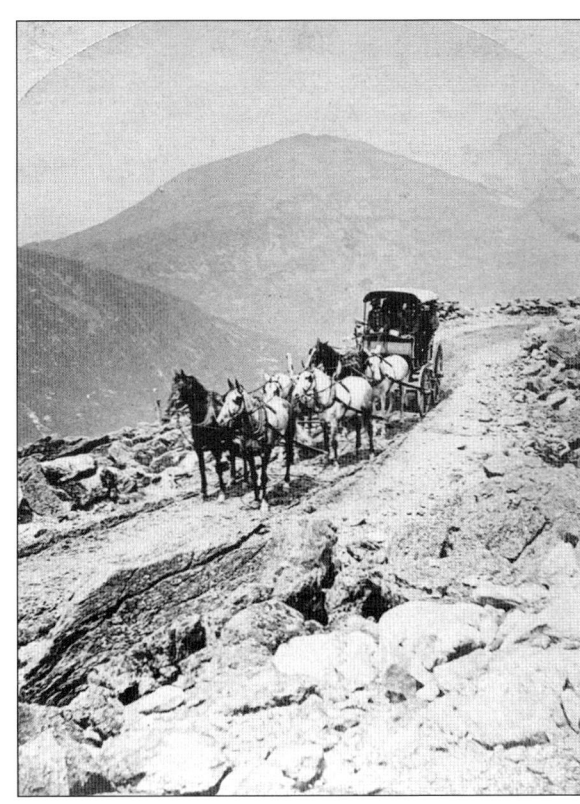

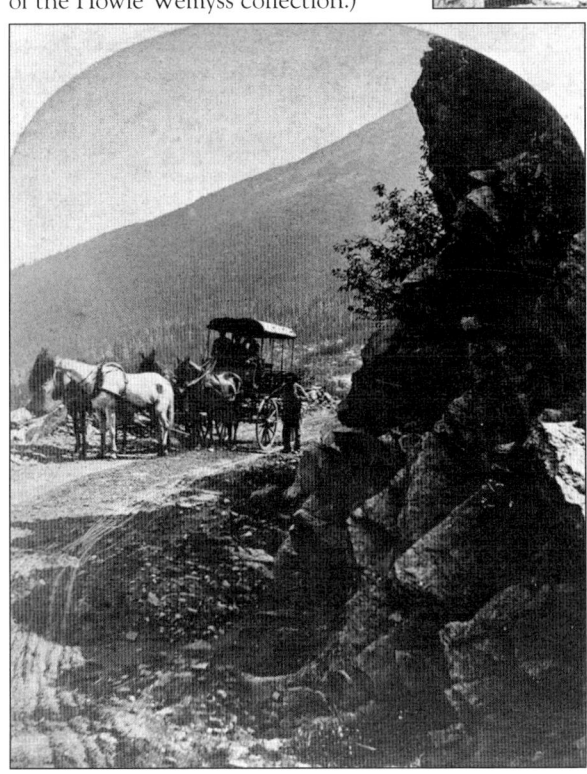

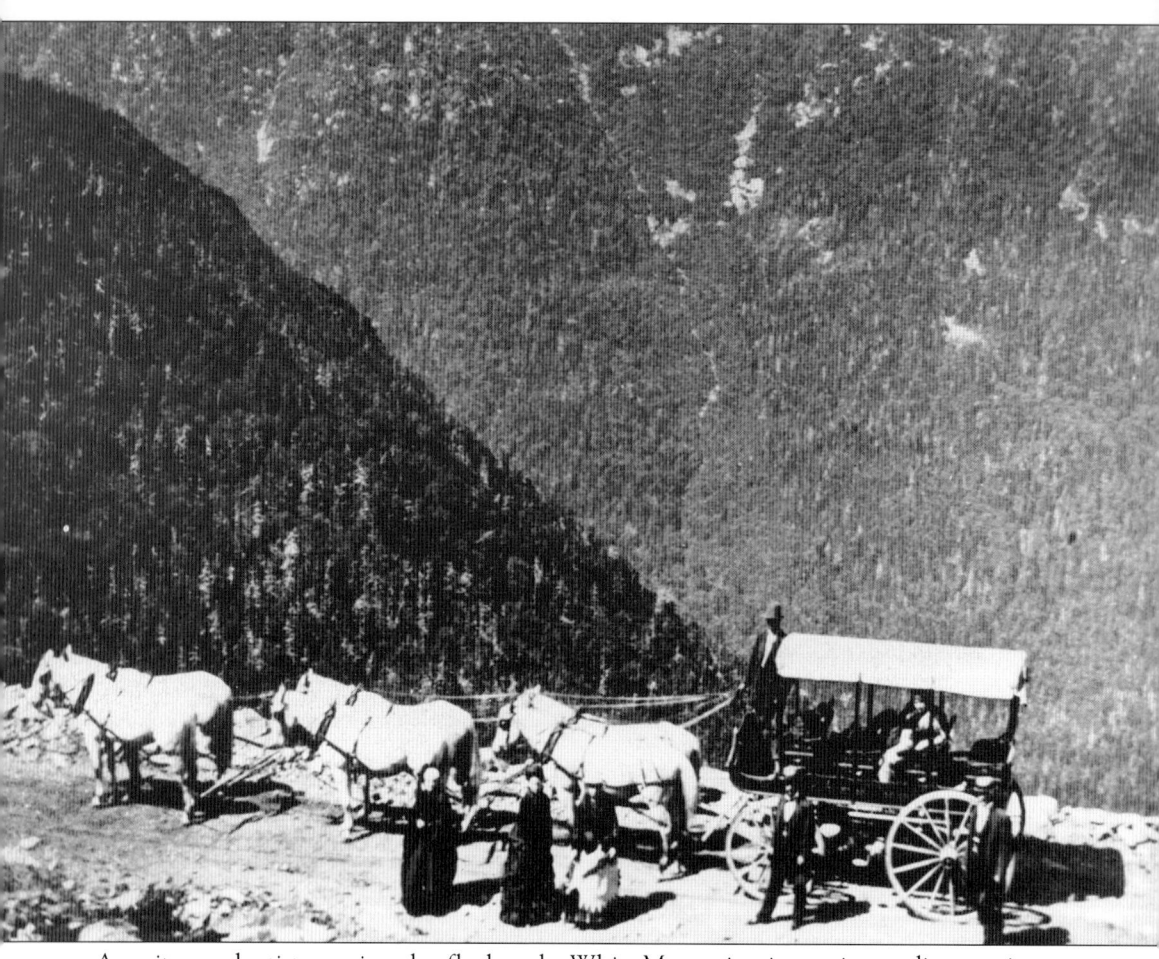

As writers and artists continued to flock to the White Mountains, increasing media attention was also generated, creating more demand for tourists wanting to experience the towering heights of Mount Washington during the summer season. In his book *The White Mountains*, Julius Ward captures the excitement and drama of the climb with this 1890 account: "The ascent of the Glen Carriage Road may be made with a team or by foot . . . You compare point with point as the landscape opens to the eye and feel as if the world were visibly increasing in size as you proceed. When the upper shoulders have been reached beyond the treeline and the roadway lies between piles of broken granite and the yawning chasm of the Great Gulf, one must put forth all his mind to assert his existence against the mighty forces of nature."

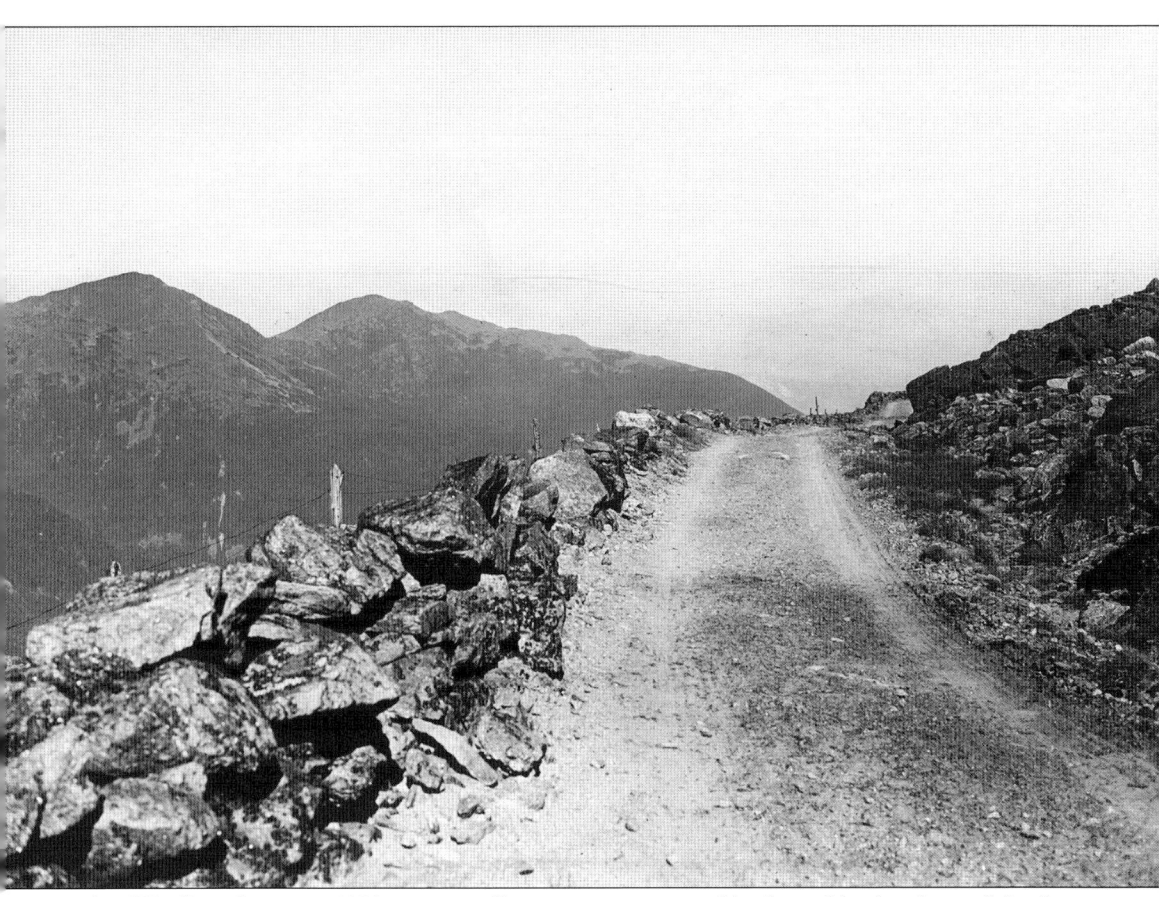

Julius Ward's enthusiastic 1890 account of his ascent continues: "At the sudden breaking of clouds all this silent grandeur will be increased a thousandfold. The Glen Road at nearly every point toward the summit reveals something in the Presidential Range that the lover of mountains would not willingly have missed." For the largely city-dwelling population of the northeastern United States, the rarified heights of Mount Washington provided a physical and philosophical perspective that inspired wondrous reactions at every turn. Benjamin Champney also established the White Mountain School of Art, which brought the first artistic interpretations of this remote mountain landscape to the outside world.

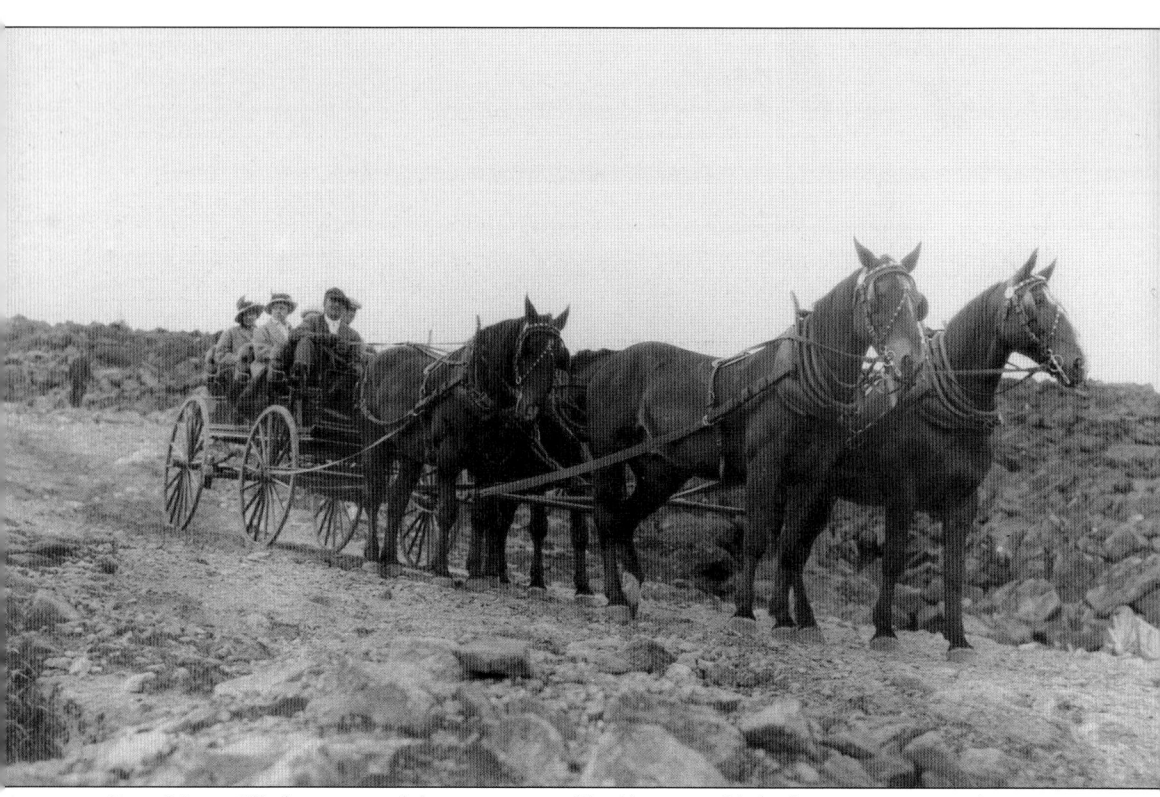

Once Mount Washington and the carriage road had been established as a true tourism destination, it seemed all roads beat a path to the White Mountains and the Northeast's highest peak. Besides the individual travelers who showed up in every conceivable horse-drawn vehicle, most hotels and inns had their own wagons and coaches that would offer drives up the mountain. Early rates for guided tours could be as much as $5, but driving one's own team was far more affordable, as evidenced by the early rate structure: 3¢ on horseback; 5¢ per person in a carriage, plus 4¢ for a two-wheeled vehicle and 6¢ for a four-wheeled, four-horse wagon. The driver in the above photograph is identified as Jim Holmes, who is near the summit.

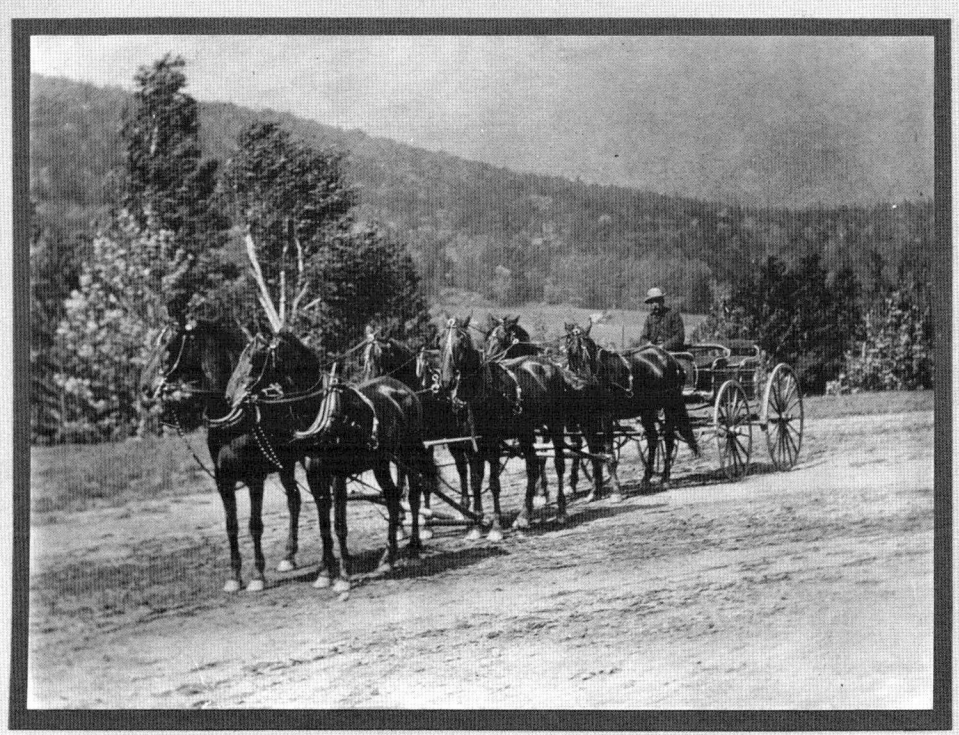

This team was driven from the Glen House to the Summit of Mount Washington August 26, 1886 by Charles E. O'Hara of Gorham, N.H. Time 1 hour 9 minutes & 27 seconds. Occupants: Dr. Seward Webb & wife of Burlington, Vt. and Col. Whittemore of Chicago, Ill.

Making or breaking a record on Mount Washington is a timeless endeavor that has drawn adventure seekers from the first day the road opened. One of the most respected and experienced of the early stage drivers was Charles O'Hara of Gorham (pictured). On August 26, 1886, O'Hara drove this six-horse team from the Glen House to the summit in the record time of just 1 hour, 9 minutes, and 27 seconds. His passengers (who left no record of their impressions of the hair-raising experience) were Dr. Seward Webb and his wife of Burlington, Vermont, and Col. Whittemore of Chicago, Illinois. O'Hara would go on to drive the famous (and only) Tally-Ho Concord Coach drawn by eight horses, which ascended the carriage road in 1899.

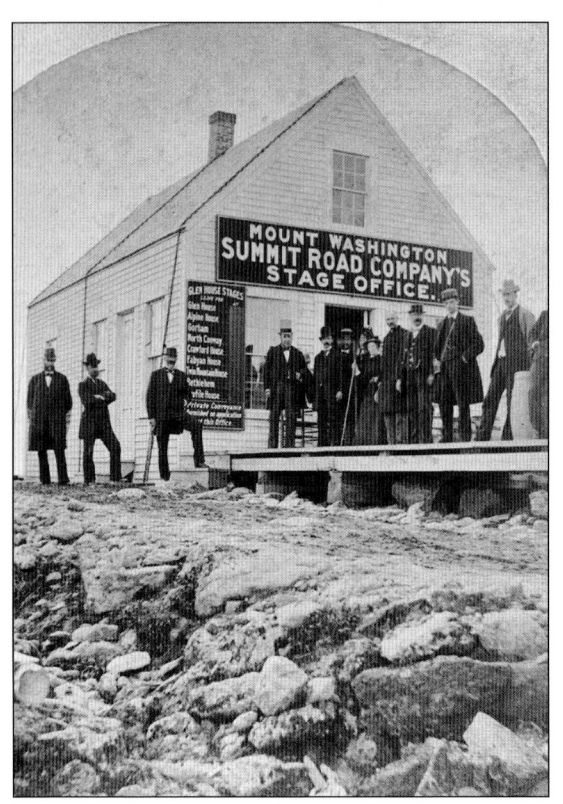

Life on New England's high point became increasingly busy as the stage business up the carriage road continued to grow each year. With hikers from the growing Appalachian Mountain Club and riders on the cog railway (which commenced operation in 1869), plus the summit hotel and Tip-Top House guests, this "city in the clouds" was quite an active scene. With the addition of an observatory tower, horse barns, a train-related shed, and the *Among the Clouds* newspaper office, Mount Washington certainly had the most unique summit life of any peak in America. The distinguished-looking group of ladies and gentlemen standing before the stage office might have been booking passage down to any of the destinations listed on the departure board: "The Glen House, Alpine House, Gorham, North Conway, Crawford House, Fabyan House, Twin Mountain House, Bethlehem or the Profile House . . . Private conveyance furnished on application at this office."

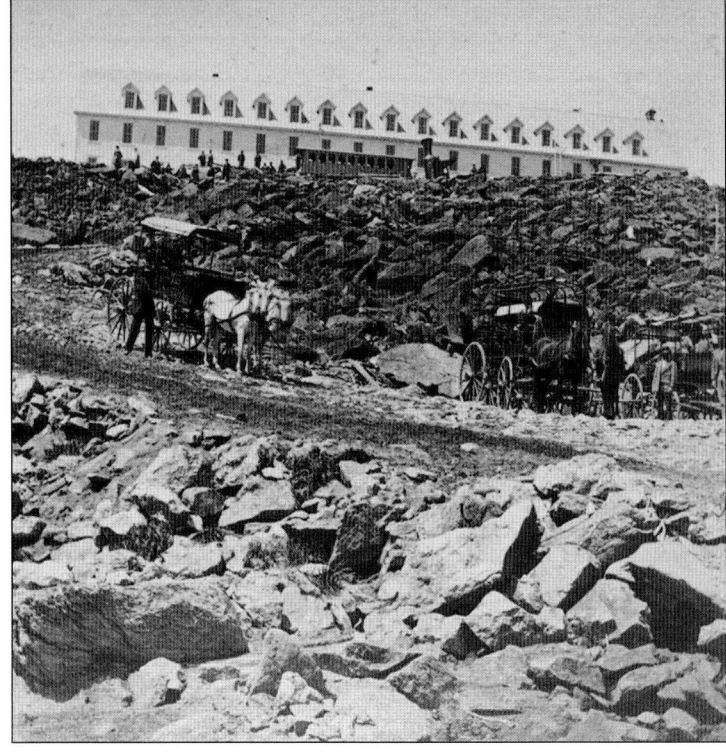

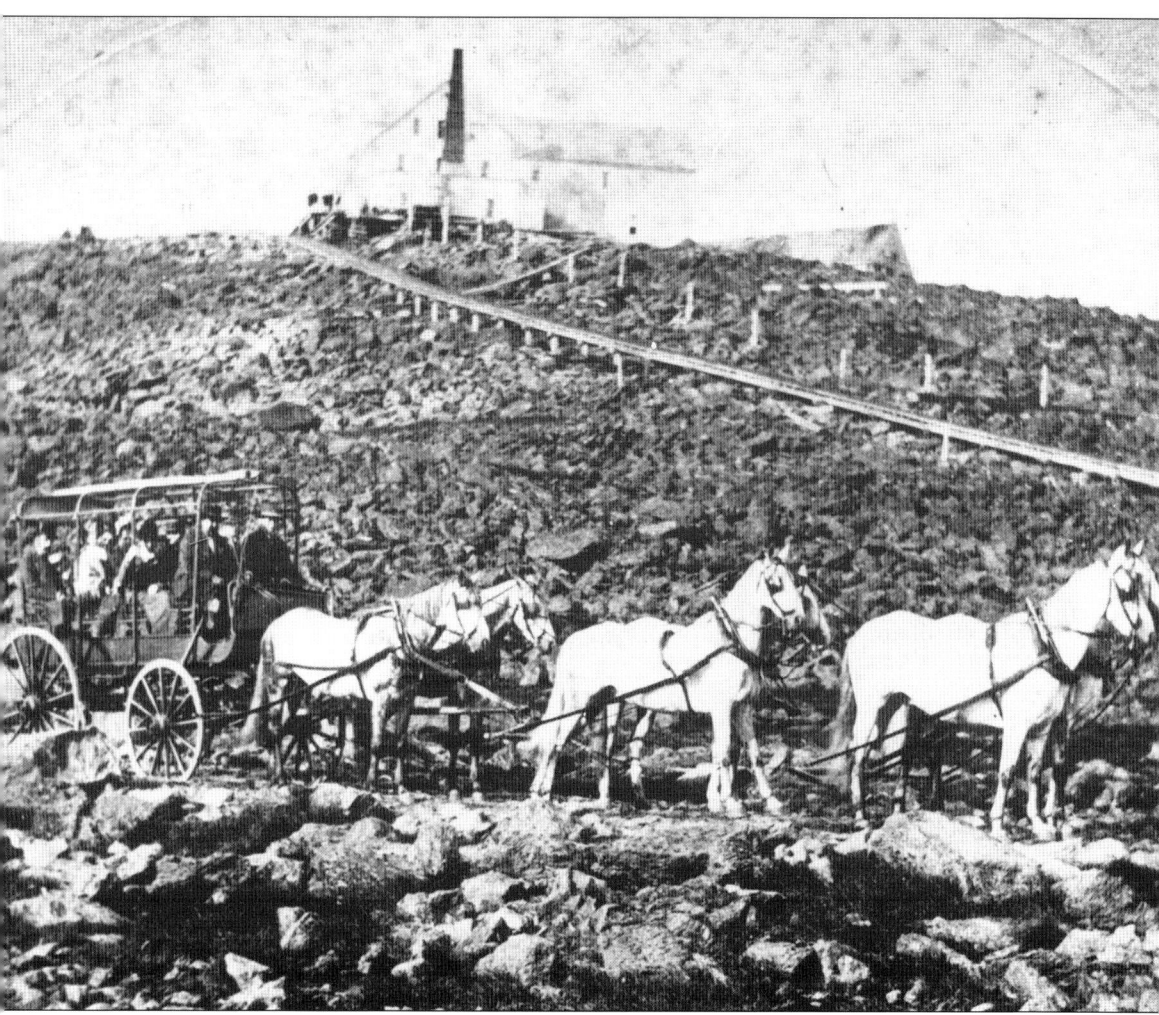

A Mt. Washington Carriage Road mountain wagon drawn by six white horses makes quite a dramatic image as it begins the descent from the summit with a full load of passengers. The journey down generally took about two hours and would burn through a complete set of leather brake pads each time. Fully loaded, the custom-built coaches could ferry 12 passengers, including the stage drivers. A group trip to the summit of Mount Washington had become a standard part of a White Mountain summer vacation, with many of the local hotel proprietors becoming well known for their horsemanship. It would always be a full-day expedition in getting to the glen from their hotel in town, then four hours up, two hours down, and finally, the return trip to town. These horsemen were considered both heroic and professional in the responsibility they took with the many lives in their care. Many references can be found recalling "the picturesque guides, with metal badges on their caps, wearing gay jackets and making shrill calls to the files of horses they led."

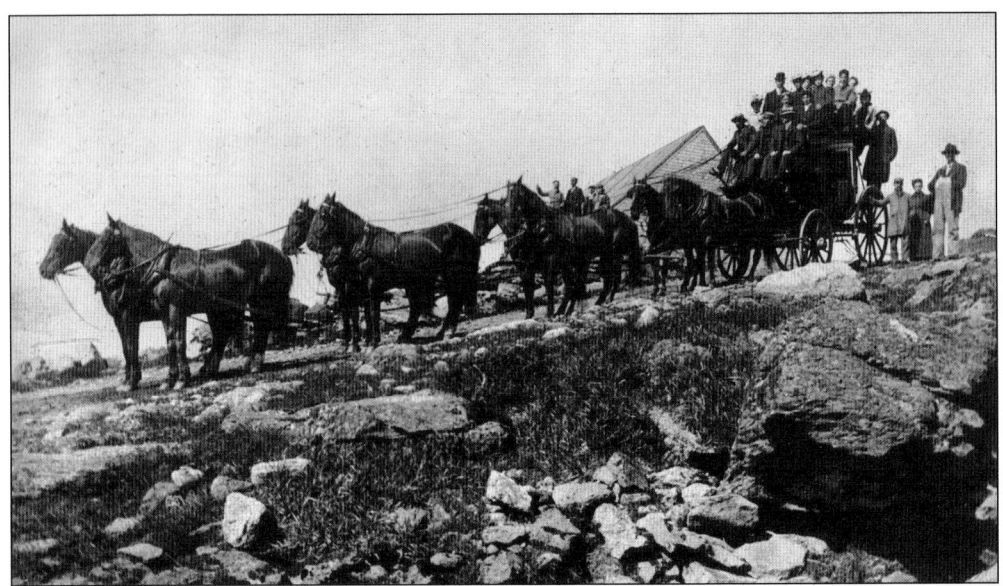

July 20, 1899, turned out to be a banner day for the Mt. Washington Carriage Road and the summit community, for on this day, Keith's Theatre in Boston sent the eight-horse Tally-Ho Concord Coach from the Fabyan House to the summit. The purpose of this journey was not only for publicity, but also to film "biograph" footage, which was to be taken by representatives of Thomas Edison's American Mutoscope and Biograph Company of New York. These earliest of motion pictures were shown throughout the leading cities of the United States and Europe, further burnishing Mount Washington's image as a uniquely compelling destination. At the time of its release, this short film was considered the most remarkable motion picture ever made and generated applause whenever and wherever it was screened. This coach, as were many of those that traversed the Road to the Sky, was built by the Abbot-Downing coachworks and delivered to the Twin Mountain House on July 4, 1870.

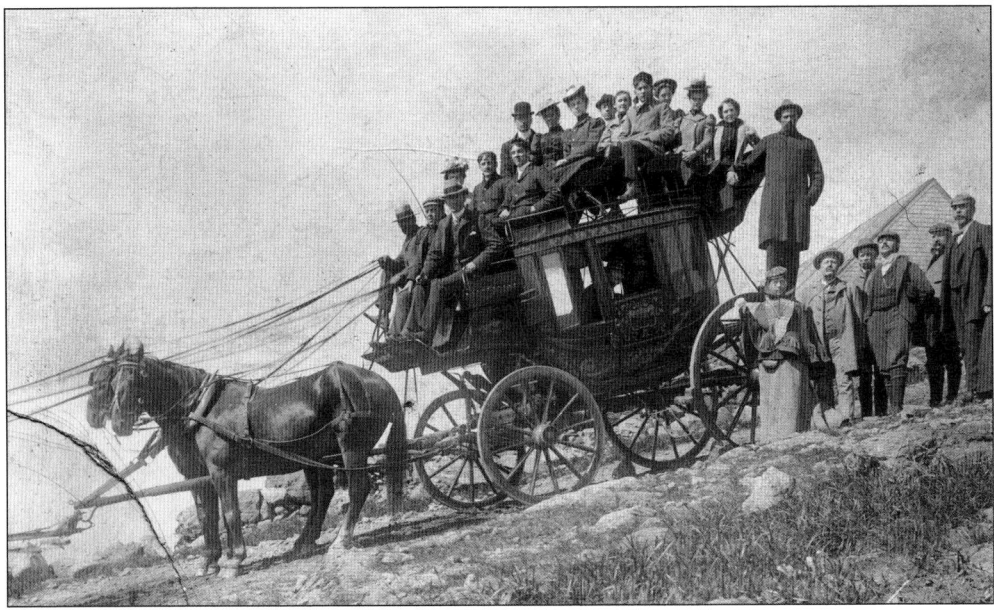

Two

THE CARRIAGE ROAD BECOMES THE AUTO ROAD

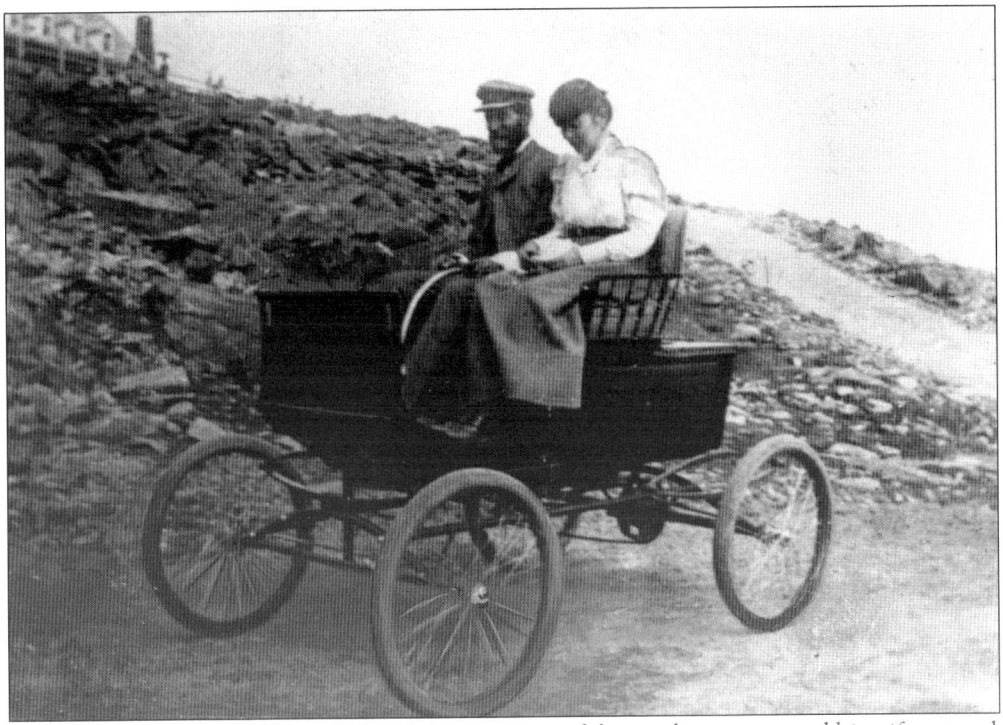

The summer season of 1899 had already been an eventful one when a man and his wife entered Pinkham Notch riding in an invention that heralded a changing world. The man was Freelan O. Stanley, who, along with his wife, Flora, drove their six-horsepower steam-driven horseless carriage dubbed the "Locomobile" to the summit on August 31, becoming the first motor vehicle to climb Mount Washington. The ascent took 2 hours and 10 minutes, besting what an actual "six-horsepower" mountain wagon could do by almost two hours.

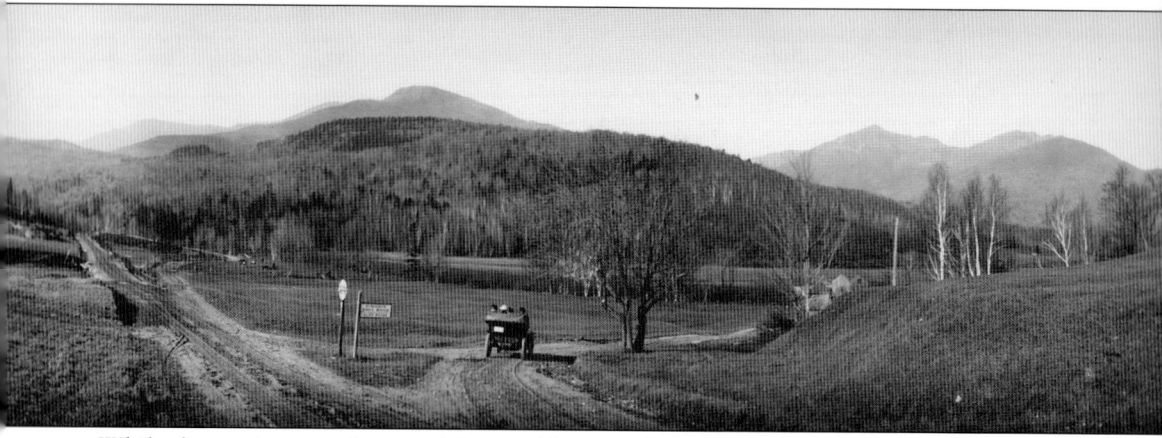

While the coming age of automobiles would prove a boon to tourism in the White Mountains, not everyone was ready to accept these radically new machines. Just a few years after F.O. Stanley's first motor vehicle ascent, as well as several others who also made the grade, this editorial was published in *Among the Clouds* (which had been published on the summit of Mount Washington since 1877): "The automobile has come to the White Mountains and those who love to drive horses must make the best of it. But, for the sake of humanity, we earnestly appeal to automobilists to keep off Mt. Washington. If an automobile should meet a carriage upon rounding one of the turns, a frightful catastrophe would follow. The next legislature should be asked to prohibit the use of automobiles on all roads to mountain summits . . . Prompt action by mountain lovers ought to save such roads from the invasion of the red devils."

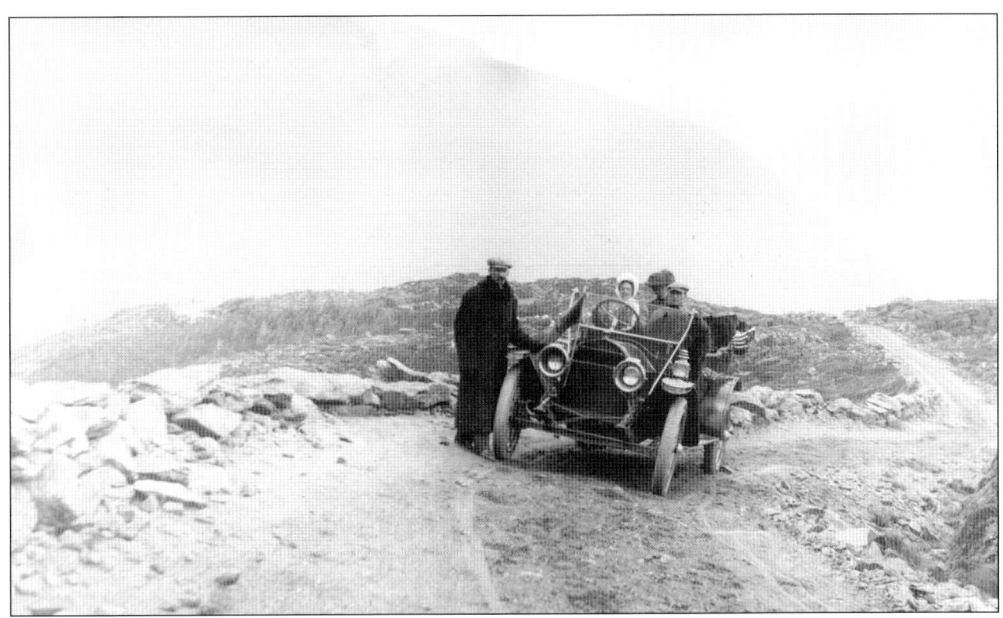

The advent of the automobile era meant that a new breed of travelers was finding their way to the top of the Northeast's highest peak. Besting the slopes of Mount Washington in a car was a mark of distinction for both vehicle and driver—and passengers, for that matter. These two Cadillacs were driven up the road in the fall of 1910, having been sponsored by G.H. Miller of the Miller Automobile Company from White River Junction, Vermont. Given the frigid temperatures found on Mount Washington's summit, hats, scarves, fur coats, and wheel chains were standard operating equipment. For manufacturers, knowing that a car could operate on this mountain became a technological test that had to be passed; even then, Mount Washington was the ultimate drive.

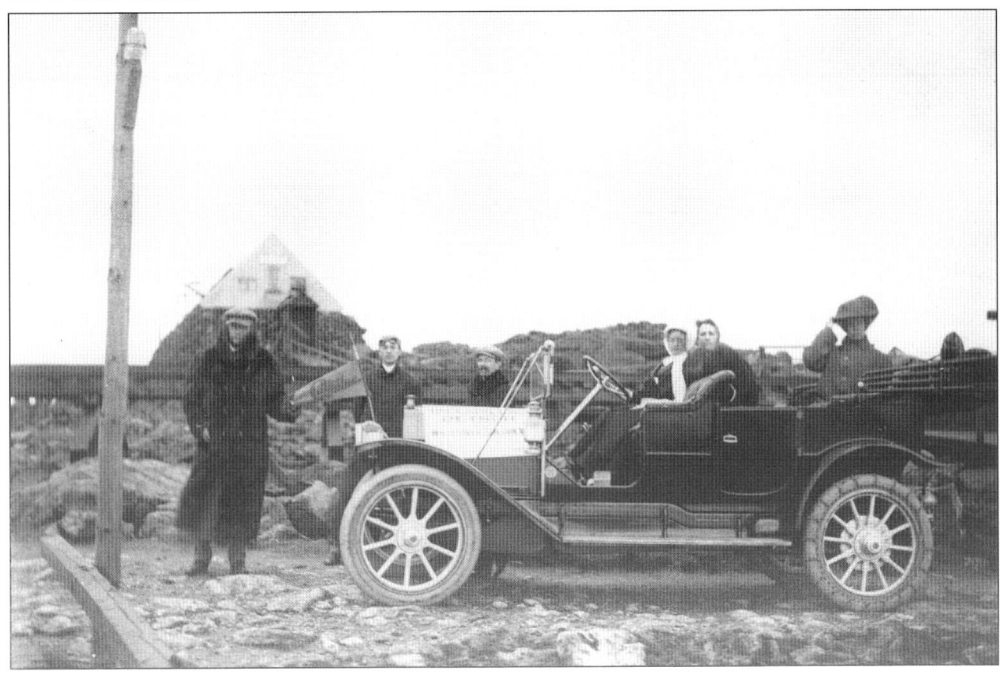

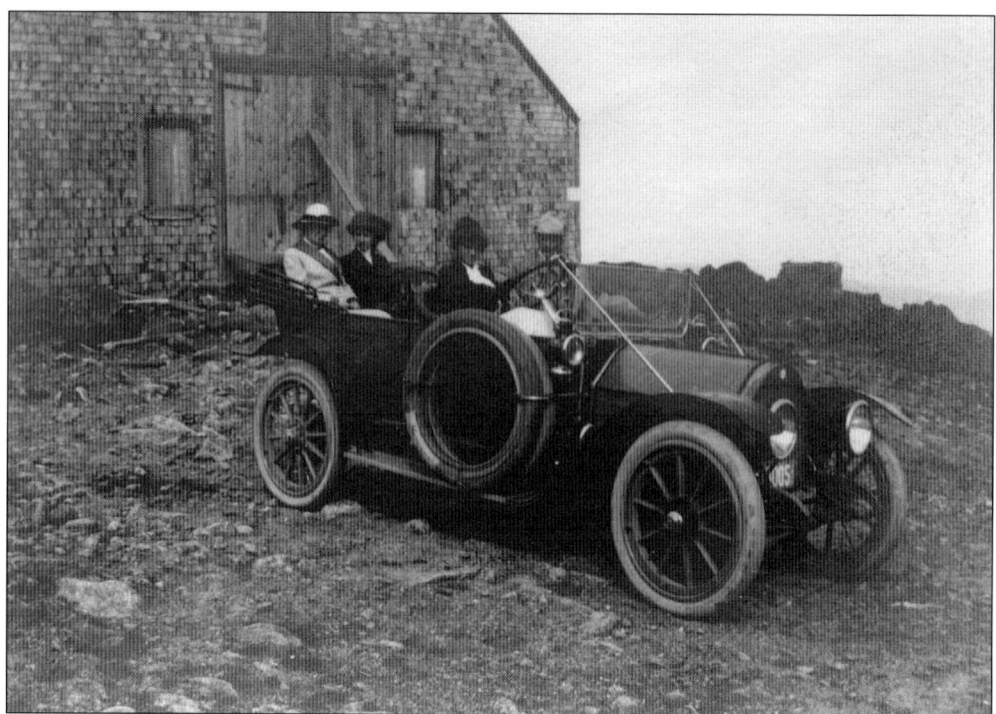

After finding an obscure reference to what might have been the first automobile ascent driven by a woman in 1913, former auto road president Douglas Philbrook tracked down Carol Nickerson 50 years later, in 1963. Nickerson confirmed her achievement of five decades before and supplied the photographic evidence to prove it. She remembered it as a nerve-racking experience, but one that made her father very proud. "It was among the first cars to switch the lights, etc. from brass to nickel, so it was very modern!" she remembered. After a stop at the halfway house to refill the radiator, which had boiled away its contents, the intrepid adventurers reached their goal and, without even knowing it, secured a place in history. The image below shows another c. 1915 automobile on a section of the road known as "Six Mile."

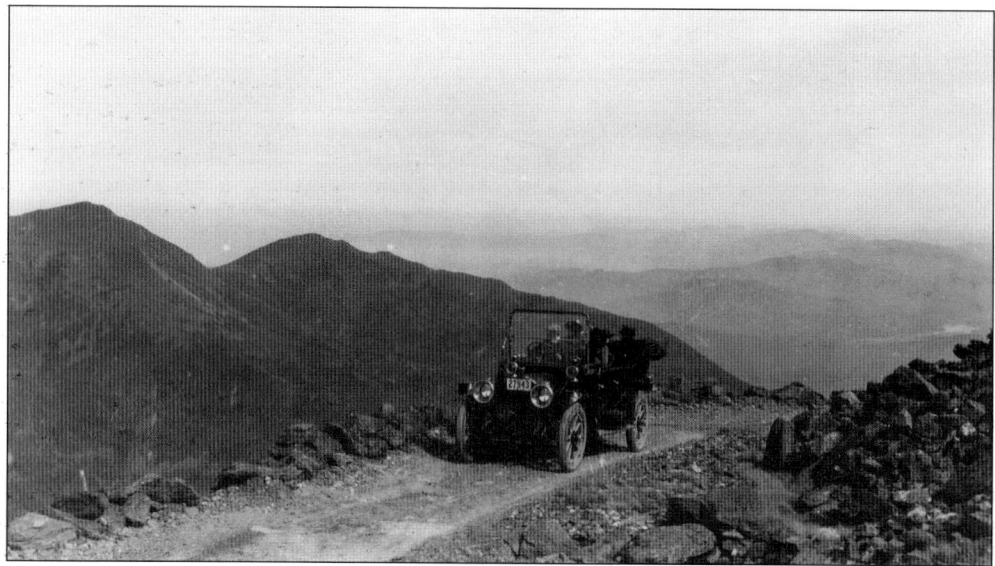

This is the only known picture that tangibly illustrates the transition from the horse-drawn era to the automobile era on Mount Washington. It took a special vote of the road's directors to allow automobiles on the road for the first Climb to the Clouds event in 1904 and 1908 before it was voted to further allow them at the discretion of the directors. At that time, it was determined that automobiles passing over all or any portion of the road shall pay $2 and all "motor bicycles" shall pay $1, plus a per-passenger fee. In 1908, a runabout car with two passengers was $3, and a touring car with four or less passengers was $4. By 1911, under 20 horsepower was $4, and over 20 horsepower was $5, plus 80¢ per passenger. The $5 rate continued until 1978, when it was raised to $6. (Courtesy of the Mount Washington Observatory.)

Given the small horsepower of early vehicles and the average driver's limited experience on mountain roads, there would often be a question as to how both would do on Mount Washington. Add in ever-changing weather conditions that could theoretically have snow and/or ice on the summit any month of the year, and nothing could be taken for granted. Note the chains on the rear wheels of both c. 1915 vehicles, which have already been to the summit and are now heading down a section of the road known as the five-mile grade. The image below captures the sun breaking through as a c. 1920 automobile makes it way over the six-mile stretch on its way to the summit.

After having run several models of vehicles as stages for the public, which included a 1908 Thomas Flyer, a Knox, a Peerless, and a Chandler, the first multi-vehicle fleet was comprised of Packards, one of which is pictured above with the doors open and a couple of drivers horsing around. Through the years, the personalities and storytelling skills of the stage drivers were, and still are, a big part of the experience in visiting the auto road. A group of dandies in striped coats (below) poses by the toll road sign in a c. 1915 Pierce-Arrow. The road later ran a fleet of Pierce-Arrows to ferry the public up the mountain.

By 1920, when the above picture was taken, horses were long gone from the auto road, and the advancements in motor vehicle technology had opened new frontiers for anyone wishing to explore America's ever-expanding road system. Even with more places to drive than ever, the summit of Mount Washington remained a notable goal for any driver venturing into New Hampshire's North Country. Stopping at the halfway house, the three men pictured above had a mischievous idea for what their time on the summit would include. It would not be the first, or last, time someone decided to invent a record they could best—and brought a camera to prove it. The image below captures a busy moment in time, about 1925, with the auto road hosting tours and private vehicles of all description.

As if just driving to the top of Mount Washington was not enough, many travelers thought it would make their visit even more significant if some sort of new record could be devised for bragging rights. That was the case for these motorists, whose names have been lost to time, but whose summit tomfoolery has been recorded for posterity. After making their way up the road, these adventurers continued right up the boardwalk, somehow navigated the steps, and turned to find themselves right at the very door of the Summit House (above), where the proprietor finally turned them away. Much to their credit, they did not leave before establishing the new altitude record for a car driven higher on Mount Washington than ever before. From June 28, 1920, this record stood until the summer of 2013, when auto road general manager Howie Wemyss drove the company's Smart Electric Drive car to within two vertical feet of the actual summit.

41

Having already survived more than 60 years since it opened, through the Civil War, the Spanish-American War, and World War I, along with competition from the cog railway and the transition to the age of automobiles, the Summit Road Company had proven more resilient than anyone imagined during the lean years before the Libby family purchased it in 1906. Their family stewardship, which continues to this day, provided an economic and ethical framework that remains in place. The scene pictured above shows a typical 1920s view of the road leading to the summit, including a comfortable-looking touring car, along with the Summit House, cog railway, and Tip-Top House on the horizon. Other than being largely paved, the winding eight-mile road to the top offers exactly the same spectacular vistas that it has since its opening in 1861. (Author's collection.)

The auto road's fame and popularity continued to grow into the 1930s as more and more people visited, took pictures, and then shared them with the folks at home. Beyond that, more and more journalists and writers featured Mount Washington in their stories about the White Mountains, in addition to a number of contemporary professional photographers who focused their work on Mount Washington and its environs. Among the best-known photographers were Winston Pote and Guy Shorey, who both spent long hours carrying heavy camera gear up the mountain, all year-round. The image above, taken by Pote, features a young couple taking in the view on the five-mile stretch of the auto road, where the halfway house and Osgood Ridge on Mount Madison can be seen in the distance.

As the road business rolled into the 1930s unfazed by the Great Depression, the future continued to look bright. By 1935, more than 4,000 cars went up the road, carrying over 9,000 passengers. The numbers stayed relatively steady through the decade in terms of cars and passengers, but the coming of World War II proved a devastating turn of events, as road traffic plummeted to 825 cars in 1942 and an all-time low of 463 in 1943. By 1946, the annual totals were back above 5,000 and have climbed steadily since. The bumper tag on the down-bound vehicle, which reads, "This Car Climbed Mt. Washington, NH," was the predecessor of the now ubiquitous "This Car Climbed Mt. Washington" bumper stickers seen on vehicles throughout the United States. The image below shows a car in a parking lot at the summit, looking southeast over a sea of clouds.

Located just past the five-mile grade on the Mt. Washington Auto Road, the notorious Cragway drifts have always been the most difficult and labor-intensive section to clear each spring. In the early years, this area was shoveled by hand—a backbreaking job when facing a wall of snow that could be as much as 30 feet high and 100 yards long. During the winter, Mount Washington Observatory snowcats and the auto road's own SnowCoach drive on top of the snow, which protects the actual road surface, many feet below, from being damaged. The image below shows a crew taking a trial run in preparation for opening the road to the public. (Right, author's collection; below, courtesy of the Philbrook collection.)

45

As the auto road motored on into the 1960s and beyond, it was firmly established not only as the nation's first man-made attraction but also as the literal and figurative high point of any vacation in the White Mountains, just as it had been since opening in 1861. The bridge shown above was originally built in 1896 over Clement Creek, a few miles north of Mount Washington in Shelburne, New Hampshire. It was replaced in 1926 and was rebuilt at the auto road's tollgate crossing over the Peabody River, where it served until 1974. The image below captures a moment in time during a pristine October day in 1967. Whether just taking in the view from the base, as many do, or driving to the summit, it is a captivating experience that each generation of the traveling public has found their own way to enjoy.

Three
WORKING ON THE ROAD

This 1908 Thomas Flyer was the first automobile used as a stage to take passengers on a guided tour of the auto road. Touring, or open-top, cars were used exclusively on the road throughout the first decades of the 20th century, offering guests an unobstructed view of the mountains around them. In later years, it was found that visitors preferred the weatherproof nature of enclosed vehicles, thus various station wagons and vans were employed.

These c. 1915 images capture a merry morning at the base of Mount Washington as a convoy of four Packards begins its journey to the summit. For most visitors, it was a moment of high excitement, with smiles and whoops of joy accompanying the departure. While road managers had used a series of individual vehicles for tours, the Packards became the first fleet. The above picture shows the four stages loaded up and ready for departure from the third Glen House. The image below shows the group just past the tollhouse. Given that the average temperatures at the summit are 30 degrees cooler than at the base, it would not have been long before the coats and hats went on!

After the Packards had served their time on the auto road well into the 1920s, next came an elegant fleet of eight used 1917 and 1918 Pierce-Arrows (one of which was found decades later by Doug Philbrook, who restored it, and it is now on display in the Douglas A. Philbrook Red Barn Museum). While there was one Pierce-Arrow "limousine" with a roof, all the rest were open-topped touring cars. The above photograph shows the whole group, loaded up with American Automobile Association secretaries and ready to begin the day's guided familiarization tour to the summit. One unsolved mystery from this image is the errant turkey in the lower left corner. Ready to head up, a Pierce-Arrow is seen in a close-up view below, at the stage office. (Above, courtesy of the Philbrook collection; below, courtesy of the Mt. Washington Auto Road.)

After a long and respectable run, the auto road's collection of Pierce-Arrows was retired and replaced with a "modern" (and enclosed) fleet of Ford woodies, which were specially modified with hydraulic brakes to handle the demands of driving up and down Mount Washington all season long. Taken on September 10, 1942, the image below illustrates the kind of issues that can occur on a mountain road. Stage driver Kak Noyes can barely maneuver his vehicle around the massive block of ledge that has slid into the roadway. One of these Ford woodies has survived the journey through time and is still up and running when not on display in the Douglas A. Philbrook Red Barn Museum at the base of the auto road.

By the 1950s, America was a nation on the move. An improved highway system and a vacation road trip in the family car had become a requisite part of summer, as reflected in the auto road attendance figures, with car count numbers jumping from 611 in 1944 to 15,088 by 1957. The passenger count increased just as dramatically, climbing from 2,237 in 1944 to 30,317 in 1957. A shiny new fleet of Ford station wagons became the new stages, and gas pumps were installed at the base (above). The image below shows one stage leaving the base and another returning from the cloud-shrouded summit.

The almost-but-not-quite-smiling man on the left in the above photograph is Charles Sullivan, the Summit Road Company and Glen and Mount Washington Stage Company manager from 1954 to 1964. Shown here talking to road foreman Ray Caron in 1956, Sullivan started at the auto road as a stage driver, even having driven a four-horse hitch as far as the halfway house as a 16-year-old. In a 1954 newspaper article, Sullivan noted that 3,000 tons of gravel was required annually to maintain the road surface, with a crew of nine men and three trucks working constantly. He estimated road maintenance costs at approximately $35,000 per year. The image at left shows one of the Ford stages above "the Horn," with the halfway house visible in the distance.

By the 1960s, a fleet of Internationals had replaced the Ford station wagons, though the old 1938 Ford woody was still showing up for the occasional drive (and photo shoot). This group of stage drivers and staff includes Doug Philbrook's future wife, Andrea, at the far right. Below is a proud group of drivers next to their vehicles at the start of a picture-perfect day on Mount Washington.

53

The above image shows a guided tour to the summit of Mount Washington, with a scenic stop overlooking the Great Gulf Wilderness Area. Designating the 5,500-acre glacial cirque as a wilderness area in 1964 was a major step in protecting the pristine natural environment, as no timber harvesting, mining, or buildings of any kind are allowed. With the exception of a few hiking trails, only the forces of nature are at work in the Great Gulf Wilderness. The image below shows a typical 1960s day on the summit. The WMTW-TV transmitting facility is seen on the left, with the Tip-Top House behind. The stage office is visible in the foreground, and the Summit House and cog railway can be seen to the right, while stage drivers wait for their passengers to return from exploring the summit.

They have been working on the auto road all the livelong day! Except for the herculean task of initially building the road during the 1850s, no job could have seemed more daunting than that faced by the early road crew each spring when it came time to clear the Cragway Drifts just beyond the five-mile grade. In the days before heavy equipment was available, work crews armed only with shovels faced snowdrifts that could be 30-plus feet tall and as much as 300 feet long. Day after day, they would be ferried up to the job site, where they would tackle the drifted-in and frozen wall, clearing the way for another season to begin.

These two images capture a moment in time around 1920, when a shovel and pick were the only pieces of equipment available to work on opening the Mt. Washington Auto Road. It was a job that could take weeks, and should one spring snowstorm come raging in (a routine occurrence on the Northeast's highest peak), the carefully shoveled tunnel through the snow would be blown in and need to be cleared out all over again. The Summit Road Company has always had a tenuous relationship with Mother Nature, requiring moment-by-moment decisions on safety and operations.

Road maintenance is a never-ending process throughout the spring, summer, and fall on the Mt. Washington Auto Road. Maintaining water bars, fixing washouts, keeping culverts clear, and dealing with freezing and thawing requires constant attention. A variety of trucks, loaders, and graders have served through the years, as evidenced by this early view of a Huber tractor, which was set up with a bucket for moving dirt and gravel as well as a cutting bar for brush along the roadside and fields. The image below shows the kind of damage a washout can do, requiring vast amounts of work to bring the surface back to a serviceable condition.

These two images illustrate that, even during the years when mechanized equipment was available to help maintain the road surface, it still came down to men with shovels. These minor washouts above tree line were commonplace, given how little of the road was paved in those years. After the dump truck in the above picture had dropped its load, it remained for the road crew to redistribute the load in preparation for the grader (below) to come in and finish the leveling process. All things considered, it took surprisingly few men to keep the road in repair, which remains a testament to the early road builder's techniques and layout of the path.

With the spring of 1961 well under way in the auto road's centennial year and the snow beginning to melt from the upper slopes of Mount Washington, general manager Charles Sullivan looks on as the road's grader, complete with snow chains, is serviced at the Cragway turn. Tuckerman Ravine can be seen to the left, as well as a small tracked snow vehicle used by the WMTW-TV crew, which had a transmitting facility on the summit. Another Tucker snowcat that was used by WMTW is pictured in the photograph below. Shift changes during the winter were performed on a weekly basis and always weather dependent, so once one went up the mountain, there was a chance the departure could be delayed.

Road maintenance, especially above tree line, would often take place during operating hours, as evidenced by this c. 1960 image of the Summit Road Company grader leveling the surface while leading a passenger vehicle. The image below, taken on May 26, 1969, shows road crew member Bob Arsenault just 10 days after bulldozing the Cragway Drifts. With the snow managed in this way, there would be less chance of a washout, as the culverts were open and would direct the water flow off the road.

The road crew has always been a special breed. Even with all the time the stage drivers spend on the road, it is the road crew that gets to know every inch of the surface intimately. It is the road crew that must face the worst that nature can dish out, brave the elements, and get this mountain byway in shape for the traveling public. Shown above in 1978, the crew included, from left to right, John Gardner (who became road foreman in 1990), Leo Rocheleau, Bob Parent, Bob Moore, and Dick Smith. The image below shows the road crew boys and their toys, which had clearly come a long way since the days of shovels and pickaxes.

By the 1970s, Mt. Washington Auto Road guided tours were being offered in specially built Chevrolet passenger vans, similar to what is still being used on the road today. Entertainment during the guided tours then, as always, relied on the personalities of the drivers, who have always been and still are among the most entertaining characters found on Mount Washington. The above image, taken in 1973, shows driver Jeff Martel about to depart for the summit. The 1978 picture below shows several stage drivers, all dressed up and with someplace to go! They are, from left to right, Mike Micucci, Dave Robinson, Al Rehberg, Howie Wemyss (who became general manager of the auto road in 1987), Maurice Laroche, and Rick Owen.

Four
THE GLEN HOUSES

When John Bellows began building his modest public house in Pinkham Notch in 1851, he surely could not have imagined the remarkable hotels and history that would follow. In 1852, the unfinished Bellows House was sold to Col. Joseph M. Thompson, who went on to create a first-class hotel on the site, renamed the Glen House. The haying scene pictured at right was taken in 1862.

Even before the Mt. Washington Carriage Road opened in 1861, Colonel Thompson was already guiding his Glen House guests up the bridle path he had built along the eastern side of the mountain. The above photograph shows a rare view of Mount Washington from behind the first Glen House. By the winter of 1865–1866, Thompson had added a long wing to the left of the main house, expanding the amenities and services offered by his "grand hotel." The image below shows the hotel in full operation, and in 1865, Gen. Ulysses S. Grant was a guest at the Glen House. A carriage road mountain wagon can be seen in the foreground.

The year 1869 would mark the end of Colonel Thompson's term at the Glen House he had created. He drowned in an autumn flooding of the Peabody River while trying to save his sawmill. The picture at right shows a busy day at the Glen House on August 13, 1869, when 100 horses and 20 mountain wagons, among other coaches and carriages, made their way up the eight-mile road to the summit. For others, a day of enjoying the Presidential Range from a nice gazebo at the base was just the ticket, as shown in the peaceful family scene in the picture below. (Right, courtesy of the Philbrook collection; below, courtesy of the Wemyss collection.)

At a time when many travelers arrived for the summer season, hotels endeavored to outdo each other in terms of service and opulence. Besides claiming the longest veranda in the world at 450 feet, the Glen House employed a small army of uniformed waiters (left), and a string orchestra played each evening. The breakfast menu alone, in addition to more typical fare, included the following: berries, oatmeal, crushed wheat, four kinds of potatoes, teas, baked beans, clam broth, corned beef hash, fricasseed chicken, veal cutlets, sirloin steak, lamb chops, pork chops, tripe, kidneys, pig's feet, creamed cod, halibut, fried herring, mackerel, and fish balls. The image below shows a few visitors enjoying a quiet moment in the Glen House parlor.

With the tables set in the Glen House dining hall (right) and an appealing display of gourds as a centerpiece, guests would be invited in for a lavish multicourse meal. After Colonel Thompson's death in 1869, the Glen House was bought in 1871 and operated by the Milliken brothers, Charles and Weston, who made major additions and improvements, eventually accommodating over 500 guests at $4.50 per day. The hospitality and beauty of the Glen House had become justifiably famous when it tragically burned to the ground on October, 1, 1884. It took only two hours and a windy day to level the massive wooden structure.

Undaunted by the devastating fire that destroyed their Glen House hotel in 1884, the Milliken brothers immediately set upon the process of redesigning and rebuilding a new Glen House on the ashes of the old. Moreover, they decided it would be ready for the 1885 season. Designed in the English cottage style by architect F.H. Fassett, stage one of the new hotel is pictured in the photograph at left. When fully completed, the three-story building had a frontage of 300 feet and covered an area of 17,000 square feet, surrounded by a 16-foot-wide veranda, which provided an elegant backdrop for guests enjoying the joys of the summer season.

The second Glen House, as it appeared before being lost to fire in 1893, is seen from behind, with smoke rising from the chimneys and a commanding view of the northern Presidential Range. The hotel featured a 42-foot-by-48-foot grand rotunda and even had an early elevator. The Milliken brothers kept a herd of 40 registered Swiss and Jersey cows on the property to supply all their own milk, cream, and butter. By this time, the servers were largely made up of undergraduates from New England colleges. The image below shows a view of Mount Washington and the start of the carriage road from the Glen House in 1884. Note the mountain wagon and coach in the lower left corner.

This early 1880s image of the second Glen House and surrounding property shows how much progress the Milliken brothers had made in establishing the hotel and carriage road as a resort destination. Many guests stayed in suites of two to five rooms, with fireplaces. The parlors were large, well lighted, and all featured open fireplaces. The first floor had dining rooms, reception

rooms, conversation rooms, card rooms, smoking rooms, reading rooms, and billiard rooms. The verandas were wide and had rocking chairs from end to end. It also featured a Western Union office and direct communication with Mount Washington's summit and all major cities. The whole property, about 1889, was valued at approximately $250,000.

Following the devastating fire in 1893 that burned the second Glen House, the Milliken brothers had had enough and decided not to rebuild. Several lean years followed, with the decision to sell the property having been made. In 1900, Charles Milliken sold the Glen House to the E. Libby & Sons Company of Gorham, subsequently selling them the carriage road and considerable acreage in 1906. What had formerly been the employee quarters for the Glen House was eventually remodeled and opened as a small hotel in 1901, and a few horses and wagons were also kept on hand to take guests up the carriage road. This c. 1900 image of what became known as the third Glen House shows the only surviving barn, which now serves as the Douglas A. Philbrook Red Barn Museum. The image below also shows the third Glen House, which burned in 1924, along with two of its three barns.

The fourth and final Glen House (so far) was built to immediately replace the last one and opened the following year, in 1925. The popularity of winter sports had begun to take hold in the mountains, which was a big change from the traditionally summer-only tourist season. The 1926 image above shows a party of skiers and snowshoers returning via horse-drawn sleigh, a rustic reminder of the bygone years. The image below shows the same building from behind, with a snowcapped Mount Washington in the distance and a car rigged with a snowplow trying to keep the parking lot open.

As more and more travelers brought their own cars to the White Mountains, the Summit Road Company somewhat expanded its on-site offerings to include the Ye Glen Tea Kettle and Art Shop, a popular lunch spot in the 1930s. Later, in the 1950s, it served as a company dining hall for the stage drivers and road crew, but eventually, it was torn down by 1959. The image at left shows a 1930s-era tourist, camera in hand, posing by one of the many signs at the base that have greeted the public throughout the years.

Into the 1940s, the fourth Glen House (above) remained a popular hotel and still the only place to get a room in Pinkham Notch. It was only a mere shadow of those grand hotels that had come before, but it kept the tradition of Glen House hospitality alive. The photograph below shows the operation as it appeared in 1949. The small house in the upper left corner was, and still is, known as the Honeymoon Cottage, which is traditionally where the general manager lives during the summer season. The stage office, located in the far right of the picture, was going through a brief period when its signage advertised "Busses to the Summit of Mt. Washington" at only $3 per person.

March 19, 1967, became yet another day that would live in infamy in Pinkham Notch, as the fourth Glen House burned to the ground. This tragic tradition had taken each of the previous three Glen Houses, going back to when the first one burned in 1884. What had been the last small hotel, restaurant, and cocktail lounge on the property was gone, despite the best efforts of the Gorham and Jackson Fire Department. The flames were fanned by the mountain winds, which took little time to claim the wooden building. Once fully engulfed in flames, all anyone could do was watch as the last of the Glen Houses went up in smoke. Today, almost 50 years later, plans are again on the drawing board for a new Glen House to accommodate the ongoing demand from a new generation of guests.

Five

ON THE SUMMIT

In 1852, the trio of Joseph Hall (who would later become instrumental in building the carriage road), Lucius Rosebrook, and Nathan Perkins constructed the first Summit House, using packhorses to transport building supplies up from the glen. When it opened as the only shelter on Mount Washington on July 28, 1852, the Summit House was an immediate attraction, drawing as many as 100 diners a day. While just dinner was $1, three meals and lodging cost only $2.50. In 1853, the Summit House hosted Secretary of War Jefferson Davis, who went on to lead the Confederacy during the Civil War. This Winslow Homer painting depicts a horseback party arriving at the summit.

Before the carriage road opened to the public in 1861, coming down from a stay at the first Summit House could be quite a precarious affair. The bridle path offered little more than a rough-hewn, rocky descent where one false step of horse or rider could result in disaster. Still, Mount Washington always has and, to this day, still provides an irresistible lure to those seeking "one of the noblest prospects that the eye can witness or the heart desire." Guidebooks of the era only added to the fever pitch of those seeking adventure, as in the following excerpt from Edson C. Eastman's *White Mountain Guide Book*: "Those who look upon the sublime diorama for the first time are so overcome by the novelty and grandeur that they do not appreciate what they have seen for some days afterwards . . . Then it rises in memory and becomes a perpetual treasure for the mind's eye."

Following the construction of the first Summit House, Samuel Fitch of Lancaster, New Hampshire, built the Tip-Top House in 1853. Made with piled rocks for walls, it was fastened down with rods and bolts to withstand Mount Washington's notorious winds. In those first years, it was thought that libations were needed to withstand the rarified air. So an "affable bartender, backed by various decanters" was considered an essential element to summit survivability.

Col. John Hitchcock, proprietor of the Alpine House in Gorham, took over the Summit House and Tip-Top House hotels in 1862, adding a peak roof to the Tip-Top House and 17 small bedrooms. The beds were filled with moss and partitioned with cotton cloth—not opulent, but quite sufficient considering the location. It was during this time that Pres. Franklin Pierce (New Hampshire's only native son to become president) made his single recorded visit to the summit. The couple pictured above, with their fine four-horse hitch, would have paid an 8¢ toll for the four-wheeled wagon and four horses and an additional 5¢ for each passenger. Going up the carriage road in the 1860s with your coach and horses: 18¢. Getting a picture taken and ending up in a history book 125-plus years later: priceless! (Courtesy of the Wemyss collection.)

The Tip-Top House has remained the most recognizable and historic of Mount Washington's summit buildings, where it is still open to the public as a museum within the Mount Washington State Park. From 1877 to 1884, it even served as the office of *Among the Clouds*, which remains the first and only daily newspaper ever published on a mountaintop. The popularity of a visit to the summit of Mount Washington continued to grow as guests of any age (who might not be able to hike) could ride up by mountain wagon, horseback, or even train.

As the only building to have survived the Great Fire of 1908, the Tip-Top House took on greater symbolic importance as a connection to the earliest days of tourism on Mount Washington. Shown here around 1910, it is in excellent repair, with a new roof, freshly painted exterior, and solid bracing against what would later be known as "the World's Worst Weather." The Tip-Top House hosted many notable celebrities and politicians of the era and also served as lodging for hotel and railway employees. It was the backdrop for countless photographs and appeared in every guidebook that referenced Mount Washington—but its days were numbered.

On August 29, 1915, another fire would wage its attack on the apex of Mount Washington, gutting the venerable Tip-Top House. As the "last man standing" despite a relentless series of catastrophes that had leveled every other structure on the summit, its sturdy rock walls could not entirely save it from the fires that marked the end of so many historic White Mountain hotels and inns. This rare, one-of-a-kind photograph, though credited to esteemed White Mountain photographer Guy Shorey, was actually taken by Augustus E. Philbrook, proprietor of Philbrook Farm Inn in Shelburne, who had been taking his guests to the summit that day in the inn's own mountain wagon.

In 1864, a few years after the carriage road had begun operation, American Telegraph Company director Col. J.W. Robinson ran a telegraph wire from the Fabyan House, over Mount Washington, to the Glen House and Tip-Top House. In doing so, communication from the summit, including news, weather, and carriage road activity, could be transmitted to interested parties, not only to the valley below, but also to anywhere else in America that had telegraph service. In 1881, a lightning strike melted the telegraph lines, though service continued thereafter. The image above shows a primitive scene in 1869. Behind the tiny telegraph office is a cairn, used to guide hikers in inclement weather.

Having established itself as a tourist destination boasting a stage service and carriage road, a railway and summit hotels, and a newspaper office and observatory, no trip to the White Mountains would be complete without seeing the "big mountain." Ongoing events kept Mount Washington in the headlines, as did the steady stream of adventurers and the occasional inventor testing his or her latest creation. Winter was, of course, a whole different story, and the world above tree line became a forbidding place, not fit for man or beast. Thus, every fall, the summit had to be winterized as the pleasant summer days of carriage rides (right) gave way to multiple trips hauling all kinds of things back down, like the wagon loaded with mattresses leaving the summit (below). (Both, courtesy of the Wemyss collection.)

The summit continued to offer something for everyone. By 1880, the buildings of this mountaintop community included a large train shed and stable for the carriage road, an observation tower for the US Coast and Geodetic Survey, and the stage office, in addition to the Tip-Top House and the Summit House. Before being torn down in 1902, the tower was New England's highest point.

The signal station in these two images also served as an early weather observatory for the US Army. In 1877, Pres. Rutherford Hayes visited the station, where he received the following greeting from the chief signal officer in Washington, DC: "The Signal Service welcomes the President to the highest office (mountain) save for one in the United States. From the Atlantic to the Pacific Coast, all is well." This was Hayes's fifth ascent of Mount Washington, having hiked it for the first time in 1834, when he was 11. (Right, courtesy of the Wemyss Collection; below, courtesy of the Philbrook collection.)

45. U. S. Signal Station, Summit of Mt. Washington.

This is an early view of the *Among the Clouds* newspaper office and old observatory tower. *Among the Clouds* began publishing on the summit in 1877, utilizing the Tip-Top House as an office for its first eight years. It remains the only newspaper ever published on a mountaintop, with its editions sent down the cog track on slideboards. The paper was published in its own building starting in 1884, until it went out of business after the Great Fire of 1908.

This 1892 view of the Tip-Top House and the "Electric Searchlight Tower," as it was called by the photographer, gives some scale to just how large a structure the tower was at 55 feet tall as well as the kind of bracing and cables needed to hold it against the howling winds. The image at right shows the operator using Morse code to "talk" with Portland, Maine, 90 miles away. Electricity was still a relatively new concept when this 36-inch, 200-ampere searchlight, powered by a dynamo driven by a 15-horsepower steam engine in the bottom of the tower, was installed on the summit of Mount Washington. It has been noted that, on clear nights, light keepers used colored slides on the searchlight to furnish "colored moonlight."

This wonderful view of the Mount Washington Summit Road Company's stage office shows an elegantly dressed group of passengers waiting for a drive down the mountain on one of "The old reliable Glen House Stages," as the sign proclaims. For many who desired to see Mount Washington, the idea of a sooty, rattling, noisy, and often dangerous train ride held no appeal, thus the steady flow of visitors would drive their own vehicle or take a guided tour on the auto road, which remains the case today. Many of the larger hotels also maintained their own mountain wagons to bring their guests to the summit. (Author's collection.)

A six-horse mountain wagon prepares to board passengers on a sunny day atop Mount Washington. The second Summit House opened in July 1873 and brought a new level of high-mountain hospitality to the summit. Built at a cost of more than $65,000, including freight charges, it required the transport of more than 250 trainloads of building supplies to complete the job. This hotel was the lively center of a thriving Mount Washington community until it, too, succumbed to the Great Fire of 1908.

The summit's "city among the clouds" that had become so familiar to generations of travelers ceased to exist on June 18, 1908, when a fire of unknown origin began in the Summit House. Fanned by a west wind, the raging inferno overtook the entire peak and destroyed every building save for the Tip-Top House, which itself would burn seven years later. The picture above shows the ruins of the *Among the Clouds* office and printing press, the only recognizable vestiges of which were the Hoe cylinder press and Alamo seven-horsepower engine. Also lost that day were the Summit House, the carriage road stage office and stables, the US Signal Service Station, and the railway engine house and carbarn.

After several years without a hotel atop the Northeast's highest peak, the company of Barron, Merrill & Barron decided to rebuild, and the third Summit House was begun in 1914. This was no small feat, as had been learned by other proprietors of Mount Washington structures. The hotel was less elaborate than the latter, but was built just as sturdily, with a massive wooden frame and rock bolts driven far into the mountain's bedrock. A dedication and flag raising took place on August 21, 1915, which brought an enthusiastic crowd to the summit.

The remarkable image above captures a special moment in time as the bell was rung and the flag was raised atop the new Summit House on Mount Washington. It had been seven years since the former hotel burned in the Great Fire of 1908, and a large crowd had found their way to the top, driving up the auto road, taking the cog railway, and hiking up with the Appalachian Mountain Club, which held a meeting on the summit. Here, Florence Hirsh breaks a bottle of ginger ale as Fred D. Maynard hoists the flag. The photograph below, also taken on the hotel's opening day of August 21, 1915, shows a group of hikers who had arrived that morning, complete with blanket rolls, knickers, and rucksacks.

Besides having a dedication and flag raising to mark the opening of the new Summit House on August 21, 1915, the Appalachian Mountain Club (AMC) held a member gathering on that day. To this day, the AMC maintains a series of high-mountain huts and trails throughout the White Mountains. This image shows the main lobby area of the new hotel, which featured post-and-beam construction, lots of windows, and comfortable chairs for all. A picture of the second Summit House, which burned in 1908, hangs on the wall over the fireplace mantel. The only men identified here are Fred B. Maynard (center) and Frederick D. Maynard (right).

The summit community recovered over the ensuing years after the 1908 fire, eventually offering virtually all the amenities it once had (save for a mountaintop newspaper). The image above shows the rebuilt stage office on the left (before the sign was up for the season) as well as Camden Cottage in the center and the Tip-Top House next to that. The enclosed stone walkway once led from the Summit House to the Tip-Top House. Presumably, the image at left shows two auto road staff members and a dancing dog in front of the stage office, which had been built to replace the 1878 structure that also burned in the 1908 inferno.

In honor of and at the request of Patrick Camden, the cog railway company built Camden Cottage in 1922 to serve winter hikers in a jam. Camden served as track supervisor on Mount Washington for more than 50 years. Legendary AMC mountain man Joe Dodge would leave a cache of supplies there at the end of each season after closing up the Lakes of the Clouds hut. The sign explains, "To you who to this cabin come, to seek shelter from the storm, of Patrick Camden have kind thoughts, with him this idea took form."

Winter is never to be taken lightly on Mount Washington, and planning an overnight on the summit during this time is not for the faint of heart. One photographer who consistently trudged out into the world above tree line again and again was Winston Pote. His photograph of Camden Cottage in April 1931 shows what a daunting place the rime-covered world can be. Built expressly as a shelter for winter hikers, Camden Cottage can literally be a lifesaver. The ice-covered stage office, seen behind and to the left, would soon become the winter quarters for the newly established Mount Washington Observatory.

The Mount Washington Observatory would take up residence on the summit of the Northeast's highest peak for the first time in 1932. This previously unpublished Winston Pote photograph is called *In the Bag*, as Pote's caption explains: "In the bag goes 14 tons of soft coal to warm the Mt. Washington Observatory through the arctic weather this winter. The observatory, or Stage Office shown in the background has been insulated against the cold blasts with eel grass quilting and wall board. A second floor has been laid over a layer of fiber tar paper. It is the first winter occupation since 1886, when the U.S. Signal Service had a station on this highest summit in New England." Carroll Noyes is caught "holding the bag."

From 1932 to 1937, the Mount Washington Observatory was quartered in the auto road's stage office. Bob Monahan, Sal Pagliuca, Alex McKenzie, and Joe Dodge initially set themselves up for one year, to coincide with the 1932–1933 International Polar Year. Having successfully manned and recorded winter's worst that first year, it was decided the effort should be continued in years to come. This required virtually full-time winter occupancy in conditions unlike anything this side of the arctic tundra. The image above shows Camden Cottage in the foreground, with the stage office/observatory behind it. Weather instruments can be seen mounted to the roof. The image below depicts the summit covered in rime. From left to right are the Tip-Top House, water tank, Camden Cottage, and railroad trestle.

This classic image taken by Harold Orne about 1934 shows the first observers in winter residence at the fledgling Mount Washington Observatory, which was housed in the auto road's stage office for five years. According to the caption, all the men are hard at work: one observer is on the roof checking the anemometer, which records wind speed; on the right side, another observer is looking at the pyrheliometer, which is used to record the total radiation received from the sun and sky on a horizontal surface; and the observer to the left is following the direction and rate of movement of the clouds by their reflection in a nephascope consisting of a black mirror.

This Harold Orne photograph, taken on October 15, 1932, shows the men of the newly organized Mount Washington Observatory working on the wiring and setting up the stage office as their home for the first winter occupation. A form of frozen fog that grows "feathers" into the wind, rime ice can also wreak havoc on delicate recording instruments, which must be carefully maintained. All the preparation was worth it; on April 12, 1934, the crew documented the highest wind speed ever recorded on earth—an unbelievable 231 miles per hour! Fortunately, the building was chained down and survived what would forever be known as "the World's Worst Weather."

By 1936, the observatory's efforts were becoming widely known and had outgrown the stage office. Undertaking to build "the strongest frame building in the United States," the team used 9-inch-by-10-inch railroad beams, 24 feet in length, with bolts anchored at least 5 feet deep into the summit rock. Double plateglass windows, overlapping shingles, two layers of boarding, two layers of paper, one layer of Cabot quilting, and one layer of fireproof wallboard made up the observers' shelter from the elements. The Mount Washington Observatory was also incorporated in New Hampshire that year, as a private nonprofit scientific institution, which it remains today.

Once established as a credible center of scientific research, the Mount Washington Observatory and Summit began to attract attention from other institutions needing to test materials in extreme conditions. In early years, the US Weather Bureau donated equipment and manpower to help grow the operation. Such companies and organizations as B.F. Goodrich, the Quartermaster Corps, the Signal Corps, the Navy Department and Air Force, Polaroid Corporation, Douglas Aircraft, and General Electric all did testing on the summit of Mount Washington. The Yankee network also did testing on the summit during the development of FM broadcasting and built a large tower antenna on the mountaintop in 1938. The "Obs," as it is known locally, stayed in the building pictured above until 1980, when it moved into its current home in the New Hampshire State Park Sherman Adams summit building.

These two aerial views of Mount Washington illustrate elements of the mountain's ever-changing summit community throughout the decades. The above image, from about 1965, shows the Summit House surrounded by the WMTW-TV facility, the Tip-Top House, the stage office, the observatory building, and, farther downslope, the Navy and Air Force testing facilities. It is a barren and somewhat industrial-looking environment, which would eventually be remade once again in the 1970s and beyond. The image below, taken during construction of the new Sherman Adams summit building in 1978, still shows the Summit House, which was taken down in 1980; the lower slope military testing facilities have since been demolished as well.

This aerial image of the upper slopes of Mount Washington clearly shows the auto road, beginning at the long five-mile grade along the lower part of the picture. Going up the right side is the pathway known as the "winter cutoff," a shortcut built for snowcats and tracked vehicles but no longer in use. Tuckerman Ravine can be seen to the left and the Great Gulf Wilderness to the right. The auto road maintains an average grade of 12 percent, rising 4,600 feet on its eight-mile course. On a clear day, one can see more than 100 miles in all directions, including five states—New Hampshire, New York, Vermont, Maine, and Massachusetts—the Atlantic Ocean, and into Canada, from the 6,288-foot summit. Hurricane-force winds (75-plus miles per hour) are recorded more than 100 days each year, on average. The lowest temperature recorded was 47 below in January 1934, not counting the windchill. The aerial photograph below shows the summit community as it exists today, with the completed Sherman Adams summit building.

Six
AN EVENTFUL HISTORY

Setting or breaking a record on Mount Washington has always been an irresistible challenge for certain types of adventure seekers. Following F.O. Stanley's first automobile ascent in 1899, a few other vehicles made the climb, finally leading to the inaugural Climb to the Clouds, which took place July 11–16, 1904. This photograph shows A.E. Morrison in his Peerless, which sped to the summit in 36 minutes, 42 seconds. (Courtesy of the Mt. Washington Auto Road.)

Having been allowed on the carriage road only by special permission of the company directors, the first National Auto Hill Climbing Competition drew 16 entries in 1904. Mount Washington garnered a great deal of media attention when the hotly contested speed record finally went to Harry Harkness in his 60-horsepower Mercedes, with a time of 24 minutes, 37 seconds, nearly four minutes faster than his closest competitor. The image above shows Alexander Winton on the summit in his four-cylinder Winton horizontal during the 1904 Climb to the Clouds. The event would return at various times for decades to come and is still taking place periodically on the auto road to this day. The current speed record stands at 6 minutes, 11 seconds. (Courtesy of the Mt. Washington Auto Road.)

Timing for the first (and subsequent) Climb to the Clouds races has always been a serious undertaking. Standing on Mount Washington's summit on July 11, 1904, are, from left to right, the following participants: R.C. Emery, Augustus Post, A.R. Pardington, Al Reeves, R.R. Ross, and J.C. Kerrison (at table). The summit run was part of an Automobile Gala Week in the White Mountains, which included the Grand Contest by the Titans of the Road in their Climb to the Clouds. Besides the 8-mile race up the mountain, participants also made a 95-mile endurance run that circled the Presidential Range. The image below shows James L. Breese after completing his summit run in his 40-horsepower Mercedes. (Courtesy of the Mt. Washington Auto Road.)

AUTOMOBILE GALA WEEK IN THE WHITE MOUNTAINS.
JULY 11 TO 16, 1904.

Rendezvous at Crawfords, Fabyan and Bretton Woods the 9th and 10th.
Grand Contest by the Titans of the Road in their Climb to the Clouds on Mt. Washington.

BIRD'S-EYE VIEW OF THE WHITE MOUNTAINS NEW HAMPSHIRE.

1. Mount Washington.
2. Mount Jefferson.
3. Mount Adams.
4. Mount Madison.
5. Mount Monroe.
6. Mount Franklin.
7. Mount Pleasant.
8. Mount Webster.
9. Mount Tom.
10. Mount Willey.
11. Twin Mountain.
12. Mount Garfield (The Haystack).
13. Mount Lafayette.
14. Mount Lincoln.
15. Mount Liberty.
16. Profile Mountain.
17. Mount Kinsman.
18. Mount Pemigewasset.
20. Mount Crawford.
21. Giant's Stairs.
22. Mount Langdon.
23. Tuckerman's Ravine.
24. Carter Dome.
25. Spruce Mountain.
26. Double Head.
27. Mount Wild-Cat.
28. Mount Carter.
30. Mount Kiarsarge.
31. Moat Mountain.
32. Bear Mountain.
33. Lower Gateway of Crawford Notch.
64. Upper Gateway of Crawford Notch.

✕✕✕ Eight miles on Mt. Washington carriage road; individual speed in climbing, July 11th to 14th.
••• Ninety-Five miles endurance run, July 15th; circling the Presidential Range and visiting Jefferson Highlands, Glen, Jackson, Intervale, No. Conway, Bartlett, Crawfords, returning to Bretton Woods and Fabyan.
♦♦♦ One-day tour, July 16th. Twin Mountain House, Whitefield, Lancaster, Littleton, Sugar Hill, Franconia, Profile House, Forest Hills, Bethlehem, Maplewood, Fabyan and Bretton Woods.

While the Climb to the Clouds was no doubt thrilling for its participants and brought a great deal of attention to Mount Washington and the carriage road, not everyone was delighted at the prospect of these mechanized contraptions on the local highways and byways, as evidenced by this excerpt from a 1904 editorial in the *Manchester Union Leader*: "The whole thing is an unmitigated nuisance... The lives and property of perfectly helpless people have been menaced for no reason other than to provide amusement for total strangers. Some drivers can be trusted—most cannot... If they think of coming up another year, let them stay in jail a couple of days and everyone will be the better for it!"

Close to the ledge and close to the edge, the c. 1920 Pierce Arrow was the ideal "top down" way to take in the views and the crisp mountain air on the road up Mount Washington. A perfectly restored survivor of the original fleet still can be found motoring around Pinkham Notch, when not on display in the Douglas A. Philbrook Red Barn Museum. (Courtesy of Mt. Washington Auto Road.)

The next Climb to the Clouds took place on July 17–18, 1905, as part of the famous Glidden Tour. Automotive technology was evolving so quickly that the competition classes kept changing. Where the previous year found racers competing purely on time and horsepower, car classes in 1905 were broken down by cost, with Burt Holland winning the $650–$1,000 class in a 10-horsepower Stanley Steamer. The up to $2,000 class included an REO, a Maxwell, and an incongruously named Electric Vehicle Company gasoline-powered car. The $3,000–$4,500 division included a Pope, a Pierce-Arrow, a White steamer, and a Columbia. Three world records were also set by Indian motorcycles that day. The image above shows several participants in the 1905 Glidden Tour in front of the third Glen House. (Courtesy of the Mt. Washington Auto Road.)

This sturdy little Marion 10-horsepower runabout, stripped down to the bare essentials, is making the grade on what was still the Mt. Washington Carriage Road during the 1905 running of the Climb to the Clouds. W.H. Hilliard took the day in his Napier racer with a time of 20 minutes, 58 seconds. It would be almost another decade before automobiles would rule the road and the horse-drawn era would come to a close. But what began as a trickle with Stanley's first automobile ascent in 1899 would end as a flood, as literally more than a million vehicles have made the journey to the summit of the Northeast's highest peak since then. (Author's collection.)

Throughout the 1920s and 1930s, records were set and broken by a succession of drivers eager to push the limits of their nerve and their car. In 1928, "Cannonball" Baker set a record with a time of 14 minutes, 49 seconds. In 1930, it fell to Ab Jenkin's Studebaker at 14 minutes, 23 seconds. In 1932, Baker bested that at 13 minutes, 26 seconds, and on and on it went, shaving off the seconds. During the late 1930s, Ford V-8 Specials dropped the time into the 12-minute range. By the 1950s, the Sports Car Club of America was sanctioning the Climb to the Clouds, which helped keep timing and safety at the highest level, as evidenced by the safety sweep vehicle prior to a race start in the above photograph. On July 15, 1956, famed car designer Carroll Shelby took to the auto road in a Ferrari 375 GP and set a new record of 10 minutes, 21 seconds. (Above, courtesy of the Philbrook collection; below, author's collection.)

The very first ascent of Mount Washington by sled dogs took place on March 30, 1926, when Arthur Walden of Wonalancet, New Hampshire, drove his team of huskies, led by the famous Chinook, to the summit and back in just over 15 hours via the snow-covered auto road. The first woman to accomplish this difficult challenge was Florence Clark of Lincoln, New Hampshire, shown above in February 1932 at the Glen House. This was the team Clark would use in April to make her successful ascent, having had to turn back on a previous attempt. In the sled are, from left to right, Elliot Libby, Eleanor Sullivan (later Appleton), Florence Murray Clark, and Jean Sullivan (later Philbrook). (Photograph by Winston Pote; courtesy of the Maureen Clark Collection.)

The above image shows Florence Clark's sled dog team, including her famous black dog, Nanook, at the Glen House during a light snowfall in February 1932. Below, Clark approaches the summit of Mount Washington after an eight-hour climb on the snow- and ice-covered auto road on April 3, 1932. One of the original observers and founders of the Mount Washington Observatory, Bob Monahan happened to be on the summit that day with his camera. In fact, that is Monahan's dog running loose in front of Clark's team, much to the later dismay of Clark's Eskimo Sled Dog Ranch owner Edward P. Clark, who wanted only purebred Eskimo sled dogs in the photograph. (Photograph by Bob Monahan; courtesy of the Maureen Clark collection.)

Deputy sheriff Lucius Hartshorn and Benjamin Osgood made the first recorded winter ascent of Mount Washington on the carriage road in 1858. It would not be until February 1907 that Norman Libby of Bridgeton, Maine, along with Algernon Chandler, became the first to climb up to the halfway house wearing skis bound with rope. Libby reported that the drifts were small mountains, and on their return, they noted an avalanche had occurred along their path. In 1913, the Dartmouth Outing Club became the first college club to make the ascent on skis, and by the 1930s, regular winter events were being held at the glen, drawing hundreds of participants, including the sharply dressed skier above.

Prior to the advent of the automobile age, winter in Pinkham Notch was a time of deep snow and few visitors. By the 1920s, this began to change, as college outing clubs and winter sports enthusiasts found their way to the White Mountains in ever-increasing numbers. John Carleton and Charles N. Proctor (both Olympians) made the first recorded descent of the Tuckerman Ravine headwall on April 11, 1931. More and more people were learning to ski, and with snow trains, an improved highway system, and better cars, the world began to beat a winter path to the auto road's door. This peaceful winter scene above, captured by Winston Pote in 1932, shows a snowcapped Mount Washington with skiers and a sled dog team in the field across from the Glen House. (Courtesy of the Mt. Washington Auto Road.)

Following the exciting skiing records being set in Tuckerman Ravine, more and more clubs and individuals wanted to get involved in this burgeoning winter sport. It culminated on Sunday, March 20, 1932, with the first Mount Washington Spring Snow Fest, which was a series of races and jumping events for both young and senior skiers. The Glen House, the Mt. Washington Auto Road, the Nansen Ski Club, and the AMC's Joe Dodge hosted the festival, the main event of which was the first-ever eight-mile race *down* the auto road. These two images show part of the enthusiastic crowds near the Glen House and at the finish line.

This action shot by Winston Pote captures a skier in midair at the base of the auto road during the 1932 Spring Snow Fest. The eight-mile race down the road that day would feature very challenging conditions, especially above tree line, described as "the four hardest miles of skiing on the continent." Wind-blown crust, ice, and huge drifts as large as ocean waves impeded the progress of skiers. A 70-mile-per-hour gale met the five expert skiers who took on the downhill challenge from the summit to the glen, but they raced down in just over 12 minutes, the first to ever do so. It was reported that 6,000 spectators cheered them at the finish line. The three members of the US Olympic Ski Team to finish first were E.J. Blood, Nils Bachstrom, and Bob Reid. (Courtesy of the Mt. Washington Auto Road.)

Running up Mount Washington is an experience that still draws thousands of athletes each year to challenge themselves and "just one hill." In 1875, Harlan Amen was clocked running up the carriage road in 1 hour, 57 minutes. This record was good enough to last until 1904, when George Foster brought it down to 1 hour, 42 minutes. For the next 30 years, no one could best that record, until Foster and the New England Association of the Amateur Athletics Union organized a 1936 race, which Francis Darrah won in 1 hour, 15 minutes, 48 seconds. The above photograph by Harold Orne captures the start of the 1937 race, which Paul Donato of Roxbury, Massachusetts, won with a time of 1 hour, 16 minutes, 24 seconds.

When it comes to running up Mount Washington, little has changed over the years, except for the number of competitors and their ever-faster times. Races that used to draw around 100 competitors in the 1960s now draw over 1,000 who are chosen by lottery from almost twice that many applicants. Whether running for a record or not, just completing the ascent is a badge of fortitude and courage for anyone who accomplishes it. The above photograph, taken by Winston Pote in 1937, shows the racers rounding the five-mile turn and entering the most exposed part of the course above tree line. The image below shows another race day on the Mt. Washington Auto Road, 30 years later on June 16, 1966. It does not take long for the pack to spread out after the start, as each racer settles into his or her pace.

The Mt. Washington Auto Road marked an important milestone in 1961, when the venerable old company celebrated its centennial. Kicking off the yearlong celebration on January 1, 1961, are, from left to right, centennial director Douglas Philbrook, Carl Shumway, and Fred Harris. Shumway and Harris, along with Joseph Cheney, made the first round-trip to the summit on skis in 1913 as part of the newly formed Dartmouth Outing Club.

The centennial celebrations for the auto road took place throughout the 1961 season, including winter and summer events, like the car show and exhibition held in June, which brought together many different eras of vehicles that had run on the road over the previous century. Jim Brady of Six Gun City, in Jefferson, New Hampshire, made a horse-drawn wagon ascent to the summit.

Other notable events during the centennial celebration included winter ski races, red flares on the summit at night, employee reunions, and the creation of various commemorative publications and memorabilia. On August 11, 1961, New Hampshire governor Wesley Powell (on right in vehicle below) also took a drive to the summit in a horseless carriage, driven by Edwin Battison of Vermont.

From the day when the carriage road opened to the public to F.O. Stanley's first motor vehicle ascent and the million-plus cars that have made their way to the top since then, the Road to the Sky has thrilled visitors who brave its lofty heights. The auto road has provided a means, motive, and opportunity to see a mountaintop that otherwise might not have been reached by the average non-hiker. They came in whatever means the technology of the day offered and left with memories that would last a lifetime.

While the world above tree line has evolved considerably since the first travelers began to find their way to the summit of Mount Washington during the early 1800s, today it still offers the same thrills and amazing vistas that the first tourists marveled at when they arrived. Generation after generation of writers and artists have tried to put into words or imagery the powerful feelings that this mountain evokes, only to find that paint, film, and the powers of articulation fail to do the job. Still, they come, side by side or arm in arm, to seek the solace and joy that Mount Washington readily provides. It is a Road to the Sky that leads one up a mountain and into oneself, creating unforgettable moments in time and history in the making. (Above, author's collection; below, courtesy of the Mt. Washington Auto Road.)

DISCOVER THOUSANDS OF LOCAL HISTORY BOOKS FEATURING MILLIONS OF VINTAGE IMAGES

Arcadia Publishing, the leading local history publisher in the United States, is committed to making history accessible and meaningful through publishing books that celebrate and preserve the heritage of America's people and places.

Find more books like this at
www.arcadiapublishing.com

Search for your hometown history, your old stomping grounds, and even your favorite sports team.

Consistent with our mission to preserve history on a local level, this book was printed in South Carolina on American-made paper and manufactured entirely in the United States. Products carrying the accredited Forest Stewardship Council (FSC) label are printed on 100 percent FSC-certified paper.

MADE IN THE USA